PUB DOGS
OF GLASGOW

PUB DOGS OF GLASGOW

*Portraits of canine regulars in
the city's world famous hostelries*

REUBEN PARIS & GRAHAM FULTON

**FREIGHT
BOOKS**

First published in the UK, October 2014

Freight Books
49-53 Virginia Street
Glasgow, G1 1TS
www.freightbooks.co.uk

A CIP catalogue reference for this book is available from the British
Library

ISBN 978-1-908754-81-3
eISBN: 978-1-908754-82-0

Typeset by Freight in Trump Gothic East & FS Clerkenwell
Printed & bound by PB Print UK in the Czech Republic

the publisher acknowledges investment from
Creative Scotland toward the publication of this book

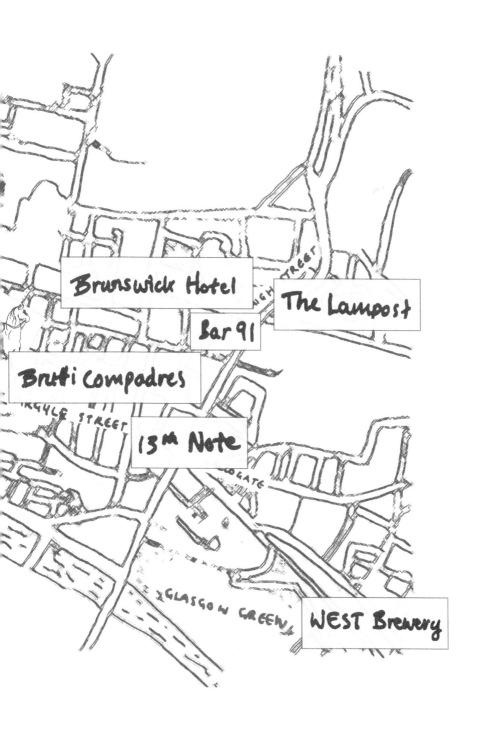

Brunswick Hotel

The Lampost

Bar 91

Brutti Compadres

13ᵗʰ Note

WEST Brewery

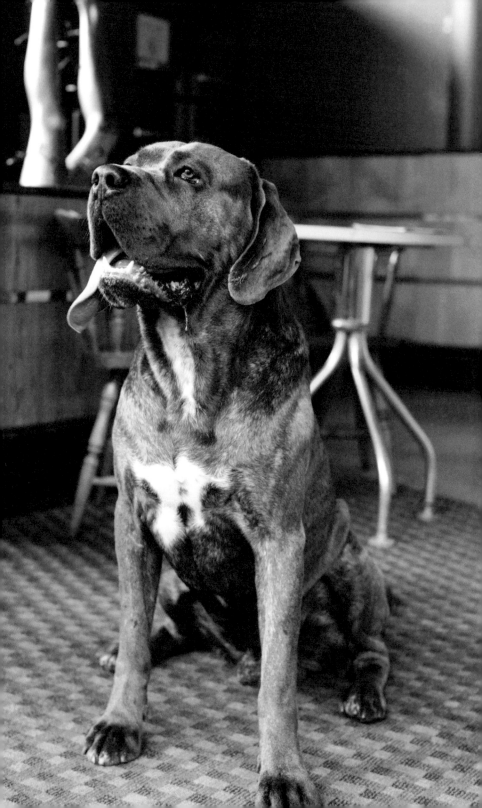

MYLO

Cane Corso

13TH NOTE

Where do they sleep?
rug in the living room

Favourite things
humping right leg of male friends
and family

Most dislikes
water sprayed on his face

Favourite place
top of the hill

Favourite drink
beer, of course

When not in pub likes to
club till late

Cats?
only curious

Best trick
slobbering all over you

Favourite toy
big rope

Favourite treat
steak

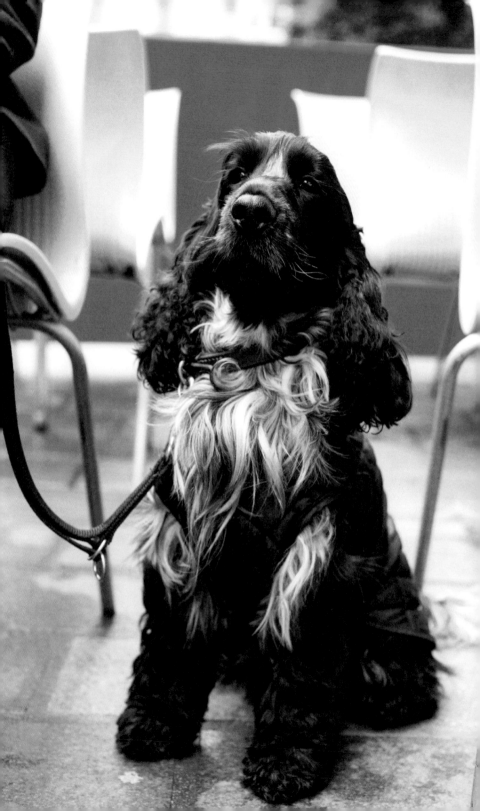

BOWIE

Cocker Spaniel

BRUNSWICK HOTEL

Where do they sleep?
in his bed in our bedroom... until
around 6am when he jumps in
with us

Favourite things
being told he's going to the park to
play with his ball

Most dislikes
getting to the park realising his
owners have forgotten to bring
the ball

Favourite place
Pollok Park – it's his Disneyland

Favourite drink
water, with the odd lick of beer off
someone's finger in the pub

When not in pub likes to
hang outside his dad's hat shop in
the Italian Centre, greeting all the
customers

Cats?
cats appear invisible to him

Best trick
keeping a secret: you can whisper
anything into his ear and he won't
tell anybody

Favourite toy
his anteater

Favourite treat
free range organic chicken from
the farmers market – he tries to eat
ethically when he can

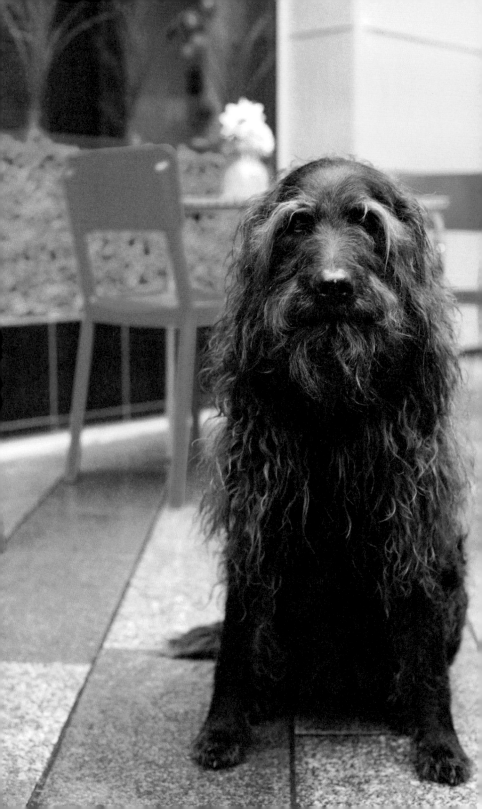

RANDY

BRUTTI COMPADRES

Labradoodle

Randy's Dream

I've fooled them.
They think I'm a Labradoodle!

I'm not.
I'm a Yeti.
Old and wise
and beguilingly hairy.

I'm sometimes mistaken
for Billy Connolly.

I wanted to see the world
 so I moved
to Glasgow.

I was tired of sneaking
on cloud-shrouded peaks,
leaving mysterious prints in
the snow.
Howling my lonely song
 in the dark.

I fibbed on my
 immigration form.

I'm quite happy just sitting here
among the orange plastic chairs
listening to the sounds of
the High Ones
as I slowly slide into sleep.

Dreaming of seaweed
and gritty Scottish sand.

You can stick your Himalayas!

Being Abominable
is not all it's cracked up to be.

RANDY

Where do they sleep?
he has four locations: his own
couch, a sheepskin rug under the
telly, a dogbasket at the end of my
bed and on the end of my bed

Favourite things
walks – retrieving sticks & balls –
chewing sticks & chews – digging
in sand – seaweed is favourite
thing in the world to lie on, chew,
chase. Swimming in sea.

Most dislikes
drunk people & junkies

Favourite place
the beach. Loves to chase foxes
in the city. Yelps & springs off
all fours.

Favourite drink
water

Cats?
will hang out peacefully with
pals' cats, rabbits & guineapigs,
but would chase them in the wild

Best trick
has looked like an old man in
a dog's outfit since he was two

Favourite toy
any soft toy with a bobbly fleece
texture he sucks & nurses after
his dinner

Favourite treat
salmon or cod or turkey

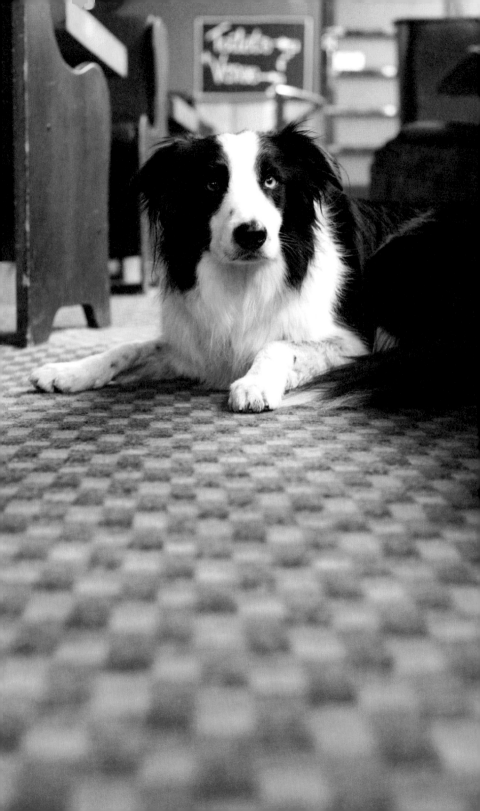

LOGAN

Border Collie

13TH NOTE

Where do they sleep?
at the bottom of the stairs

Favourite things
running, tennis balls (Wilson #3s),
sun beams

Most dislikes
having his hair or teeth brushed.
Not a big fan of the bath either.

Favourite place
at the door watching the world
go by

Favourite drink
Guinness

When not in pub likes to
run, Logan loves to run

Cats?
he's indifferent to most, although
he quite likes Cocoa the brown
brutish shorthair

Best trick
he loves to run with me on my bike.
It's a sight to behold. Fast as fu*k.

Favourite toy
has a blue bowl he quite likes

Favourite treat
real meat

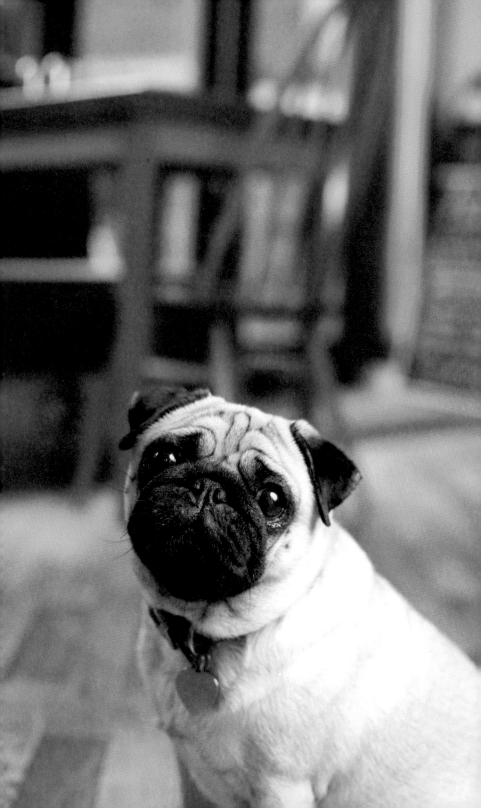

LOLA

Pug

BRUTTI COMPADRES

Where do they sleep?
wherever she likes: it's Lola's world
& I just live in it

Favourite things
pizza, park, wrestling with other
pugs, belly rubs, cheese

Most dislikes
puddles, rain, getting her face
wrinkles cleaned

Favourite place
Brutti Compadres

Favourite drink
kitten milk (as a treat)

When not in pub likes
to sleep

Cats?
loves cats

Best trick
rings the bell to get out for a wee

Favourite toy
Mr Foxy

Favourite treat
cheese

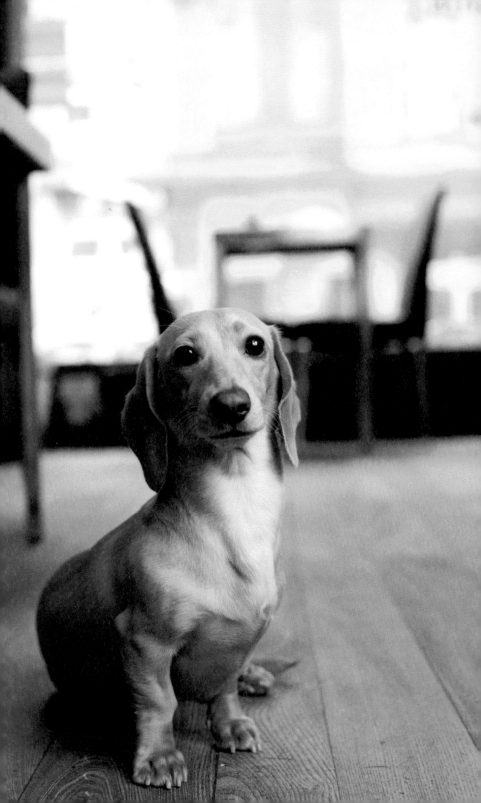

DARCEY

BRUNSWICK HOTEL

Dachshund

Darcey's Profile

This is my best side.

Or is it the other?

No matter.
They're both great.

Floppy ears and soulful eyes.
How can I fail?

I'm gorgeous!
Gorgeousity made manifest!

This could be my big break.
This time next week
I could be doing dog food
commercials
or auditioning for a part
in 101 Dachshunds.

Mulholland Drive.
Sunset Boulevard.

It's such a long journey,
especially when you're
so close to the floor to begin with.

This is definitely my best side.

Nothing's going to stop me.

All right Mister De Mille,
I'm ready for my close up.

DARCEY

Where do they sleep?
in the hall

Favourite things
her teddy

Most dislikes
birds

Favourite place
the beach

Favourite drink
water

When not in pub likes to
chase the kids

Cats?
never met a cat

Best trick
playing football

Favourite toy
teddy

Favourite treat
pigs' ears

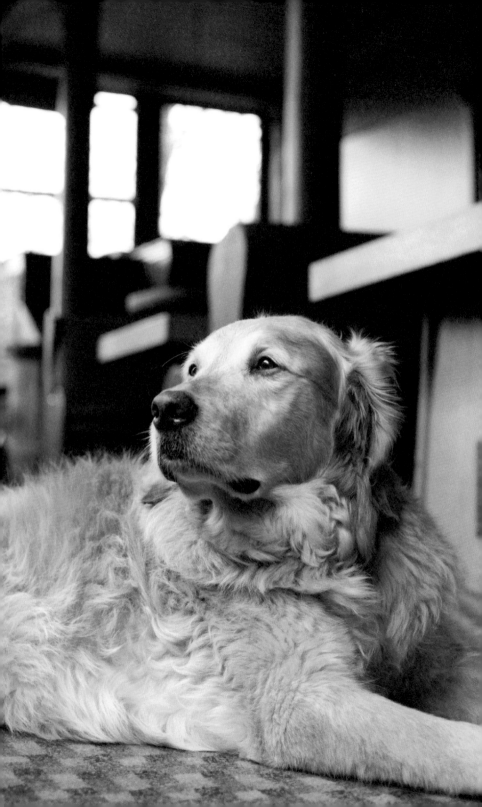

HENRY

Golden Retriever

13TH NOTE

Where do they sleep?
anywhere

Favourite things
love, affection, food, sleep

Most dislikes
the hoover, the shower, salad

Favourite place
in the way

Favourite drink
soy milk

When not in pub likes to
explore & hunt for dropped kebabs

Cats?
has a healthy respect for cats

Best trick
stick destroyer extraordinaire

Favourite toy
people

Favourite treat
whatever Peat the Whippet has

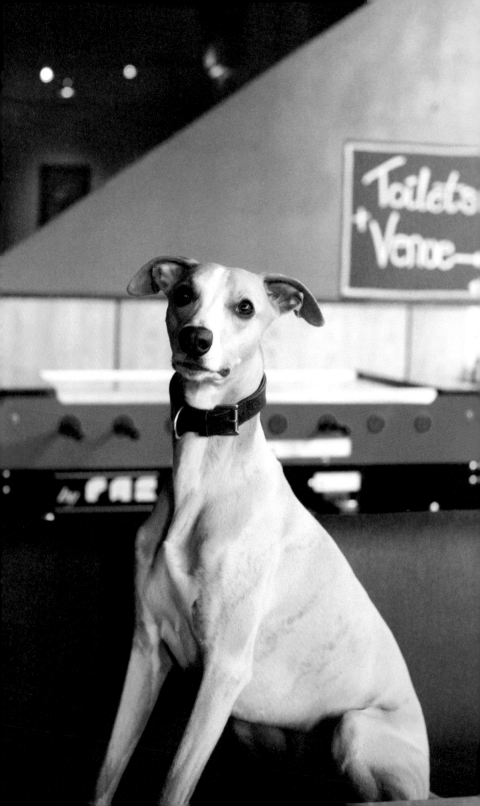

PEAT

13TH NOTE

Whippet

Peat's Table

Who wants a game of table
football?

Please

I really want a game of table
football.

Everyone assumes
because I'm a dog
I don't have the necessary
important skills
or understand the serious rules
or can't maintain the fast reaction
hand-
and-eye co-ordination required
to make a feasible attempt
at meaningful combat.

It's true,
I don't

but it doesn't stop me wanting.

Wanting to belong.

I can't play pool either
and I'm crap at Karaoke.

Who wants a game of chase the
stick?

Please

I really want a game of chase the
stick.

PEAT

Where do they sleep?
anywhere, everywhere, but at
nightime: in my bed

Favourite things
toilet rolls, bras, balloons, high heel
shoes, singing the blues

Most dislikes
hoover, being told off, nails
getting cut

Favourite place
the Necropolis

Favourite drink
cold tea or the head of a pint
of Guinness

When not in pub likes to
sleep, goad bigger dogs into
chasing him, look out the window

Cats?
he was born in a house with
cats but now just seems to find
them curious

Best trick
kiss

Favourite toy
whatever's new, favourite toys
tend to be destroyed quickly

Favourite treat
cheese

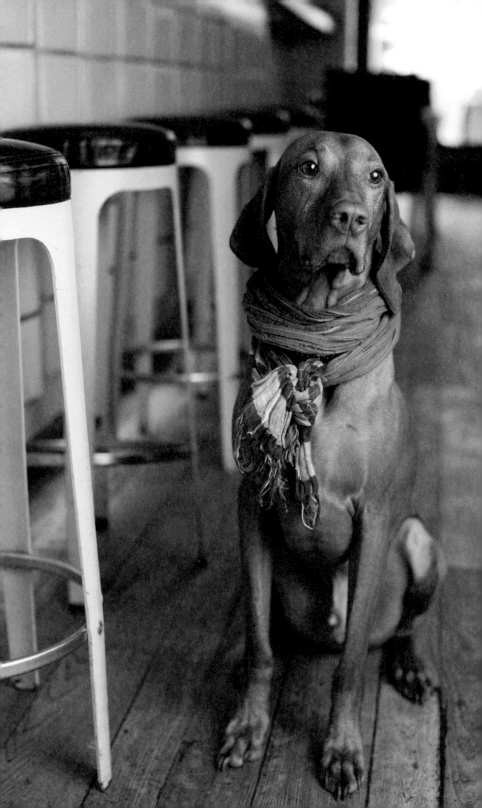

SONNY

BRUNSWICK HOTEL

Hungarian Vizsla

Where do they sleep?
sofa first, then tries to sneak into
bed at 5:30am

Favourite things
swimming, picking up plastic
bottles, chicken in the Brunswick

Most dislikes
motorbikes & loud cars

Favourite place
any beach, river or loch

Favourite drink
milk

When not in pub likes to
go to the office or for a big walk

Cats?
loathes

Best trick
swimming under water

Favourite toy
anything he fancies at the time

Favourite treat
chicken

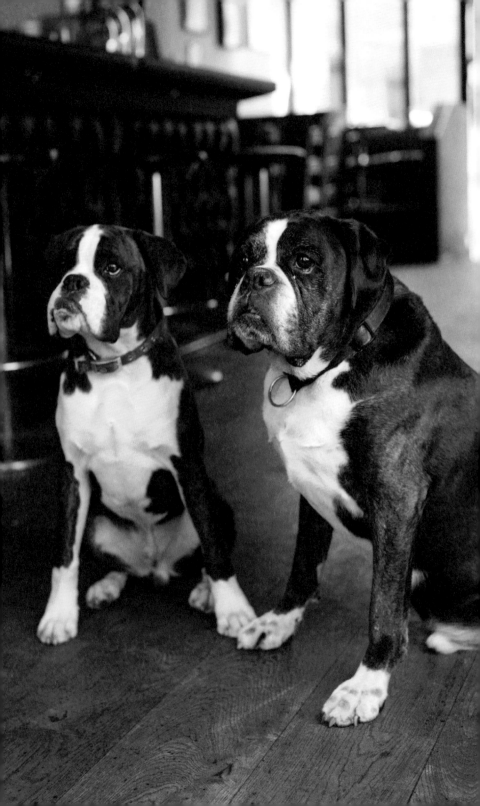

FRANK & HENDRY

CHINASKI'S

Boxers

Where do they sleep?
anywhere – preferably in the sun

Favourite things
company, chasing deer,
& children's footballs

Most dislikes
lots

Favourite place
Troon Beach

Favourite drink
water & Guinness

When not in pub likes to
cruise around the parks

Cats?
not fussed

Best trick
finding their way home

Favourite toy
anyone's hairbrush

Favourite treat
ice cream & spending time
with each other

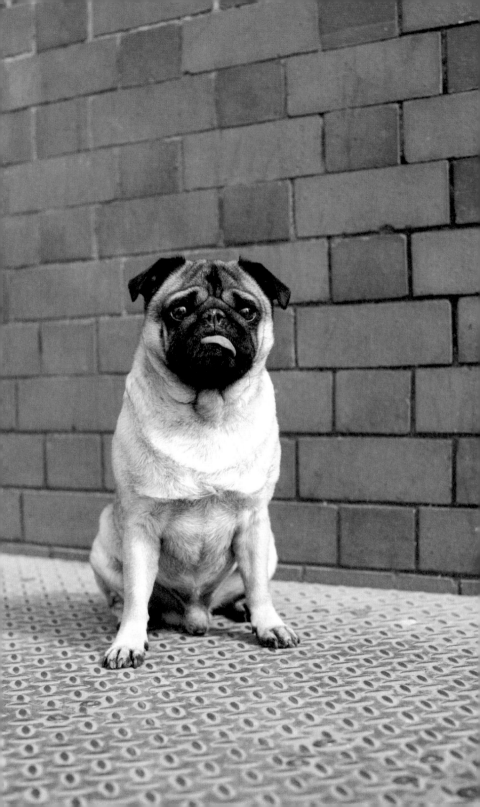

ELVIS

Pug

WEST BREWERY

Where do they sleep?
in our bed or his favourite sun trap

Favourite things
chicken & cuddles

Most dislikes
being alone

Favourite place
wherever I am

Favourite drink
milk

When not in pub likes to
eat, get cuddles, play with his rope toy while pretending he's a big dog

Cats?
thinks they are weird looking dogs

Best trick
sits for chicken, looking cute

Favourite toy
rope toy

Favourite treat
guess? (Chicken)

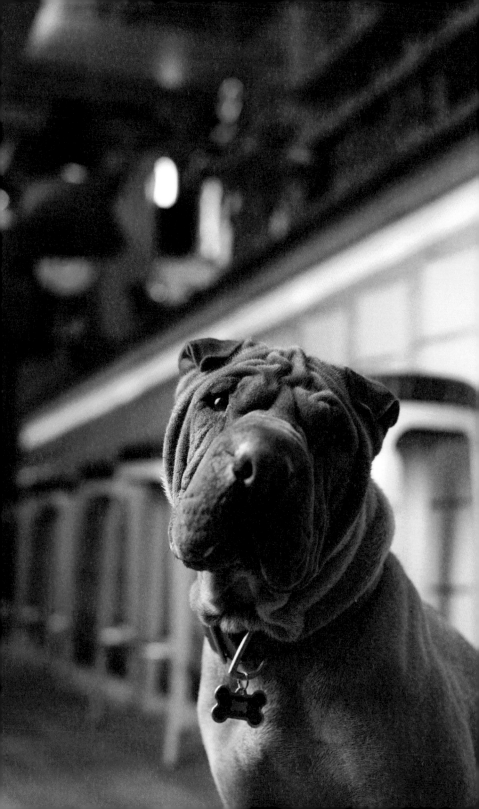

BUMBLE

BRUNSWICK HOTEL

Shar Pei

Where do they sleep?
starts in her bed, but always ends
up at my feet

Favourite things
the beach, peanut butter
& other dogs

Most dislikes
water

Favourite place
city centre, loves people

Favourite drink
Baileys

When not in pub likes to
chase squirrels

Cats?
LOVES cats

Best trick
high five followed by high ten

Favourite toy
Hamish the Highland Cow

Favourite treat
Baileys

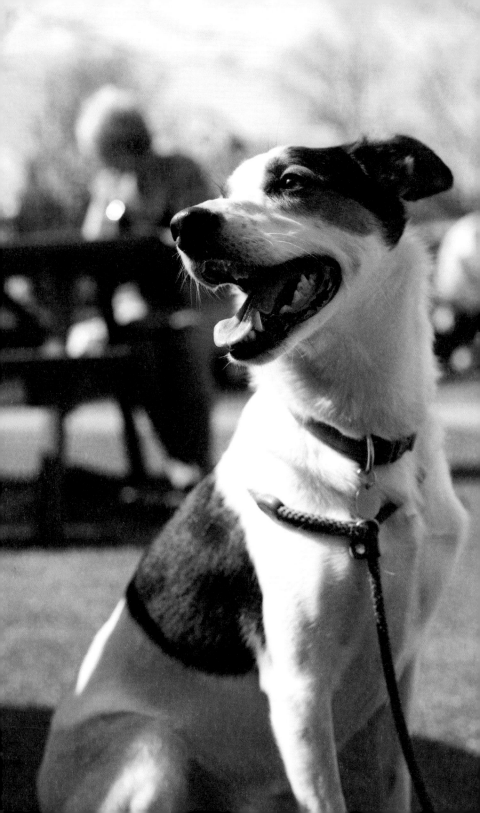

DOUG

Mixed

WEST BREWERY

Where do they sleep?
in his bed or on the couch

Favourite things
tennis balls, pigs' ears, dirty
puddles, fox poo

Most dislikes
waiting for the train

Favourite place
the park – any park – all the parks

Favourite drink
H_2O

When not in pub likes to
chase tennis balls, play with
his kitten buddy, Walt; lick bath
water from your legs; bark at the
front door

Cats?
loves cats – see above

Best trick
the double high five
& being handsome

Favourite toy
anything that squeaks
– but I hide them

Favourite treat
pigs' ears or sausages

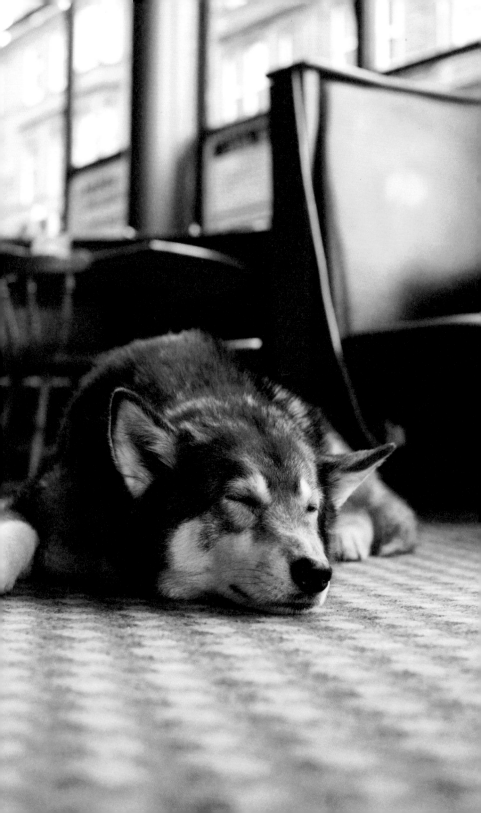

EICKE

Siberian Husky

13TH NOTE

Where do they sleep?
by the door

Favourite things
rabbit hunting / car journeys /
Jumbones / well endowed alpha
males

Most dislikes
alpha females / castrated male
dogs

Favourite place
Glasgow Necropolis & the
13th Note

Favourite drink
rain water that has accumulated
in the Necropolis

When not in pub likes to
walk for miles

Cats?
undecided

Best trick
playing tig with crows
tombstones, hide & seek
in the Necropolis

Favourite toy
they're all dead!!!

Favourite treat
Jumbone

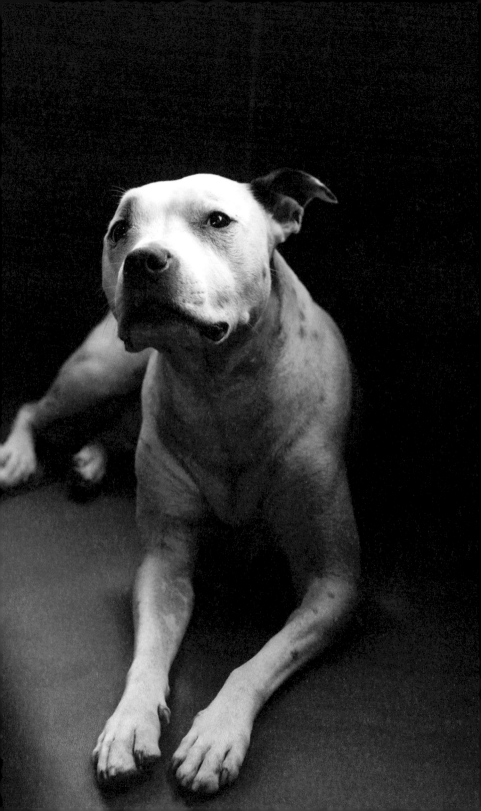

SOPHIE

13TH NOTE

Staffie Cross

Where do they sleep?
in the bed at my feet

Favourite things
dog chews

Most dislikes
shop shutters being pulled down

Favourite place
the beaches of the North Highlands

Favourite drink
water

When not in pub likes to
sleep & dream of the beach

Cats?
she loves everything & everyone

Best trick
doing the doggie paw handshake

Favourite toy
any tennis ball (that's why she's
banned from Wimbledon)

Favourite treat
Schmackos

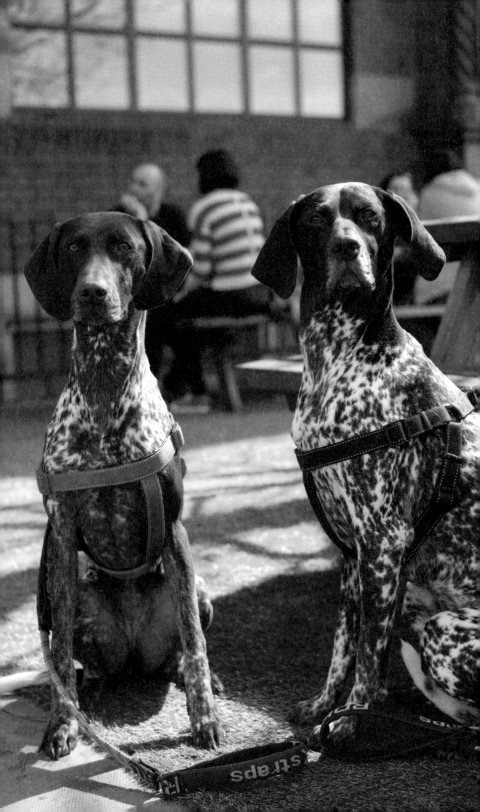

MORAG & LUCY

German Short-Haired Pointers

WEST BREWERY

Where do they sleep?
in their own bed beside
wife & I's bed

Favourite things
food, exercise, cuddles,
sleep, Glasgow Rangers,
singing & dancing, karaoke

Most dislikes
absolutely nothing. They see
the positive in everything.

Favourite place
any beer garden

Favourite drink
Baileys, on the rocks

When not in pub likes to
contemplate going to the pub to
socialize & getting "Mortal!"

Cats?
complete indifference

Best trick
read tarot & juggle 3 pint glasses
(full of course!) with no spillage!!!

Favourite toy
The Financial Times
with an ice cold Baileys

Favourite treat
The Financial Times
with an ice cold Baileys

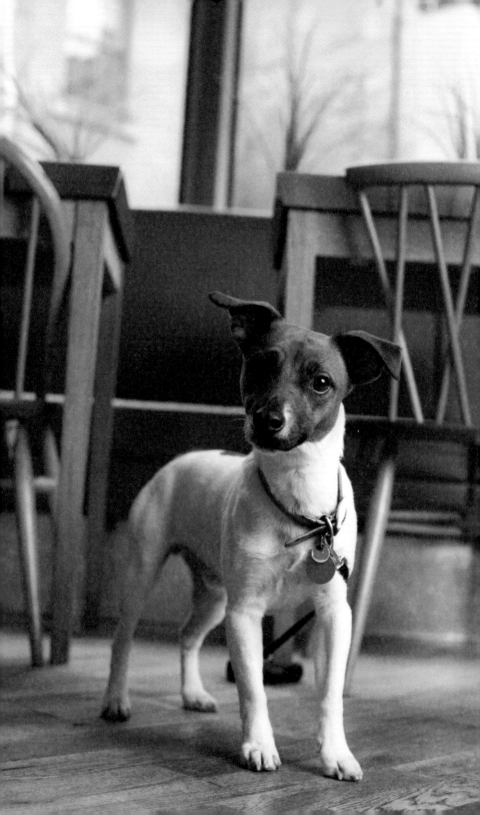

FERGUS

BRUTTI COMPADRES

Jack Russell

Where do they sleep?
in the bed with us! Spends half the night moving between the top of the covers & underneath!

Favourite things
belly rubs. Playing with the big dogs in Glasgow Green. Meeting people who will rub his tummy!

Most dislikes
small dogs, getting a bath, the hairdryer

Favourite place
under the covers at the bottom of the bed

Favourite drink
West St Mungo / Merlot

When not in pub likes to
chew toys, sleep on the sofa

Cats?
hasn't ever met one – don't think he would like them

Best trick
walking on hind legs – all for a treat!

Favourite toy
a minion from Despicable Me

Favourite treat
anything bacon!

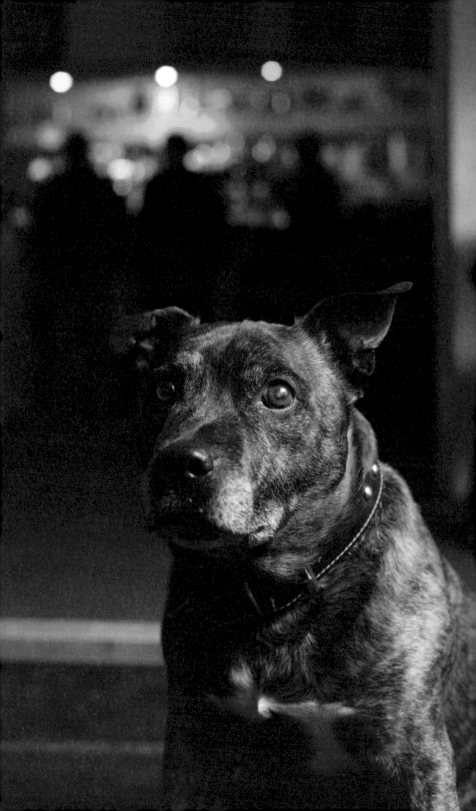

BUSTER

THE LAMPOST

Staffordshire Bull Terrier

Where do they sleep?
anywhere

Favourite things
traffic cones

Most dislikes
motorbike

Favourite place
The Green

Favourite drink
water

When not in pub likes to
go walks in the park & meet up
with his other doggy pals & sniff,
sniff, sniff

Cats?
scared of cats

Best trick
swinging leash

Favourite toy
chocolate

Favourite treat
dental sticks

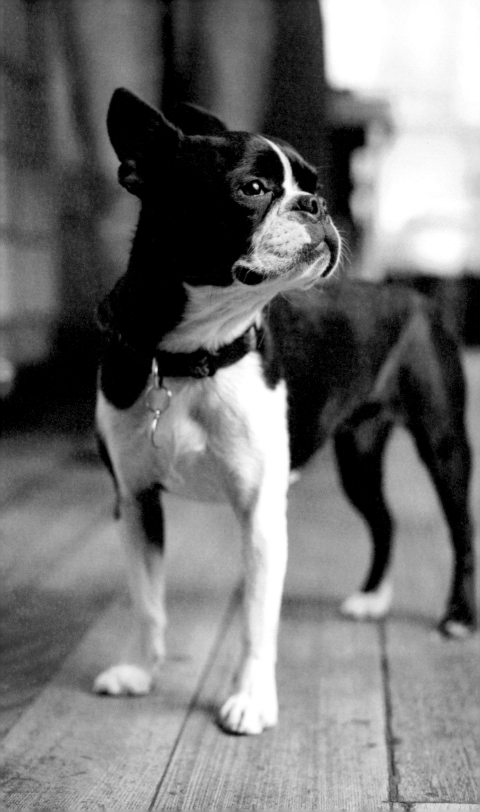

OPIE

Boston Terrier

BRUNSWICK HOTEL

Where do they sleep?
in my bed

Favourite things
sleep

Most dislikes
getting up, haha

Favourite place
park

Favourite drink
milk

When not in pub likes to
play

Cats?
she's not sure

Best trick
singing

Favourite toy
blanket

Favourite treat
chicken

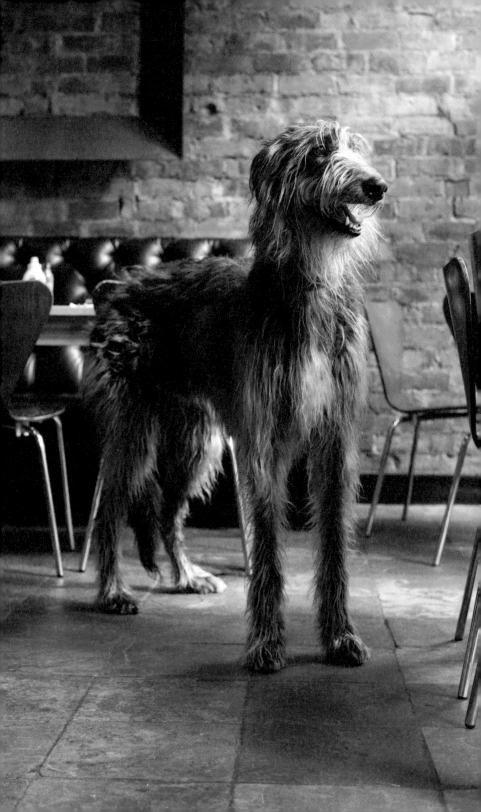

PEPLOE

BAR 91

Scottish Deerhound

Where do they sleep?
on the sofa in the kitchen

Favourite things
chasing rabbits. Cheese
– anything dairy. Sitting soft.

Most dislikes
baths. Vets. Food with no
treats in it.

Favourite place
the spa. The hill.

Favourite drink
Balvenie

When not in pub likes to
run. Sleep. Be attended to.

Cats?
chases cats, loves them, infatuated

Best trick
drinking tap water in the bathroom
– keeping the occupant company

Favourite toy
the children's toys

Favourite treat
duck strips

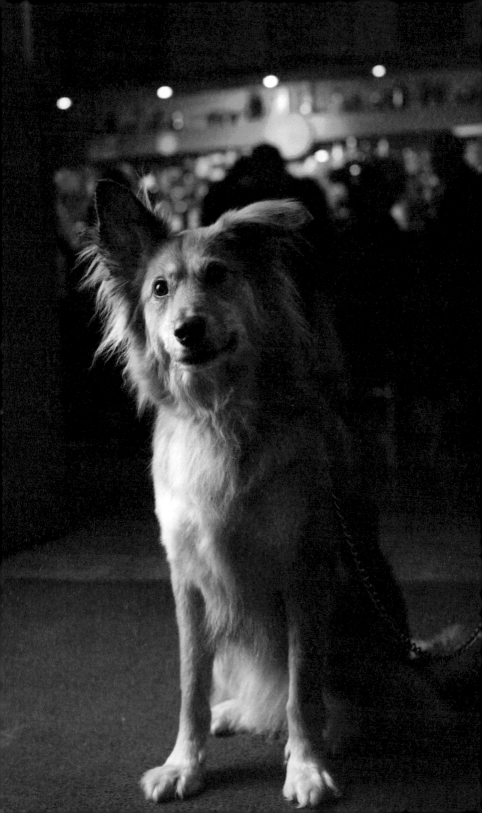

LOLA

Collie & German
Shepherd Cross

THE LAMPOST

Where do they sleep?
dog bed (daughter's room)

Favourite things
Xmas pudding, squeaky toy

Most dislikes
rain!

Favourite place
park

Favourite drink
water

When not in pub likes to
go to park

Cats?
loathes

Best trick
paw up

Favourite toy
Xmas pudding

Favourite treat
Gravy Bones

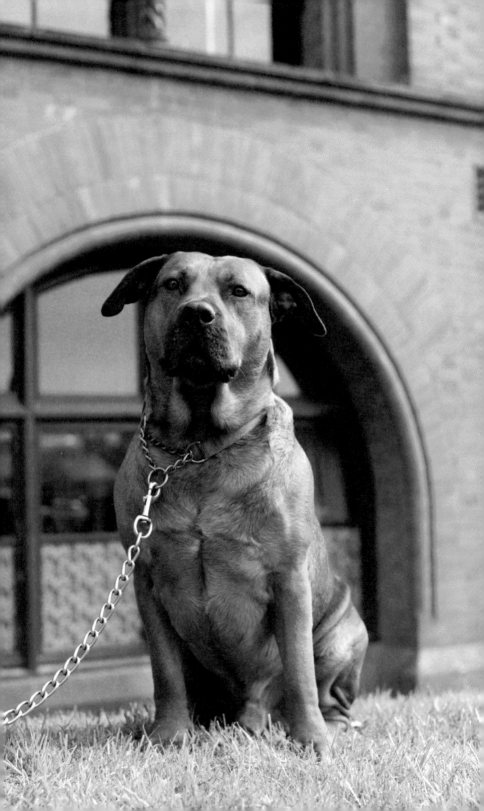

COCO

WEST BREWERY

Boerboel & Labrador Cross

Where do they sleep?
sofa

When not in pub likes to
play

Favourite things
squeaky toys, balls

Cats?
likes to chase them

Most dislikes
loud noises, big vehicles

Best trick
gives a paw

Favourite place
parks

Favourite toy
squeaky toy

Favourite drink
water

Favourite treat
biscuits

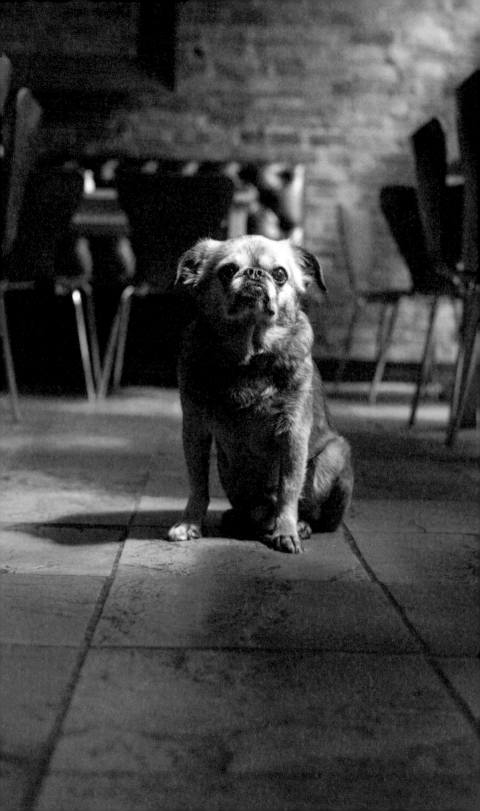

SPROUT

BAR 91

Petit Brabançon

Where do they sleep?
under the duvet with mum & dad

Favourite things
custard creams, granddad,
watching other dogs on TV,
listening to Morrisey in the car,
walking slowly in the rain, foxes,
mum, dry shampoo, a good brush,
& people watching. Oh, & ice cream

Most dislikes
snow, sea wind, fireworks, puppies,
being in fancy dress, loud noises,
drums, baths, vacuum cleaner, the
clothes horse, plastic bags, people
being too close, or visits to the vets

Favourite Place
any park, on the sofa, or under
the duvet with mum & dad

Favourite drink
tea

When not in pub likes to
be anywhere that doesn't involve
a harness or a lead

Cats?
has only had one cat experience
& he is now terrified

Best trick
convincing the world he is adorable

Favourite toy
his oinking can

Favourite treat
Schmackos

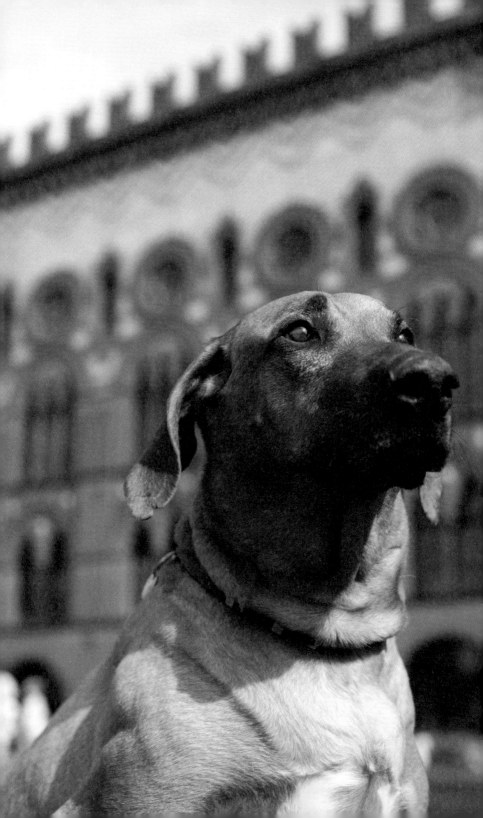

ROGUE

WEST BREWERY

Rhodesian Ridgeback

Where do they sleep?
in my bed

Favourite things
toast

Most dislikes
nothing but cats

Favourite place
West Brewery

Favourite drink
goats' milk

When not in pub likes to
sleep, eat & repeat

Cats?
hates cats

Best trick
sings to Lady Gaga
& wipes his paws

Favourite toy
mine

Favourite treat
cookies

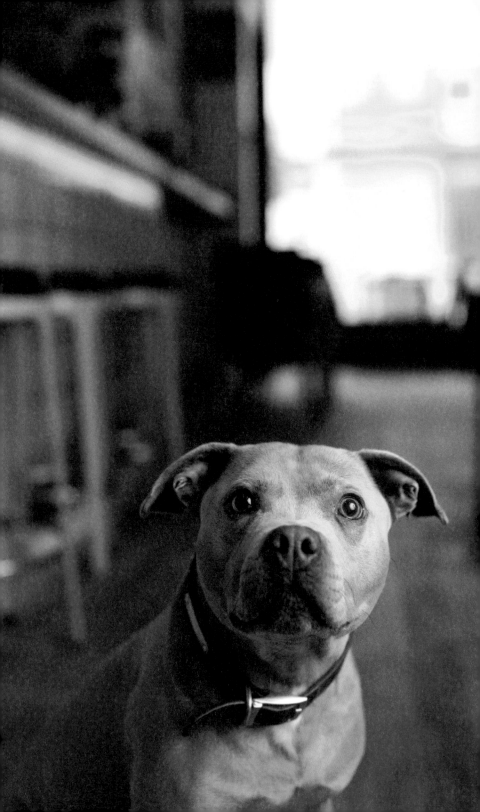

JASMIN

Staffordshire Bull Terrier

BRUNSWICK HOTEL

Where do they sleep?
loves to sleep in bed with us

Favourite things
plastic bottles, cuddles & her best
buddies Olivia, my two year-old
daughter & Sol

Most dislikes
loud noise & drunk people

Favourite place
on top of me or my partner

Favourite drink
nice cold water

When not in pub likes to
be running free at the park

Cats?
she doesn't really see many
cats but when she does she
tries to avoid them

Best trick
paw, lol

Favourite toy
anything that makes a noise

Favourite treat
anything that's not her dinner

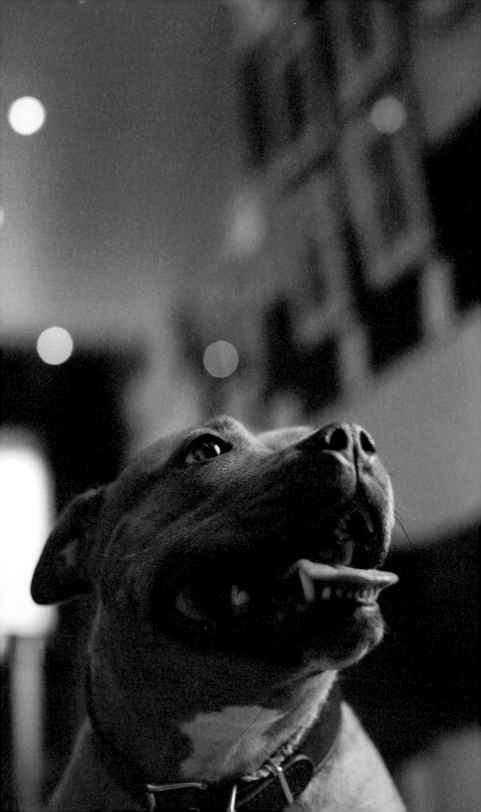

SOL

BRUNSWICK HOTEL

Staffordshire Bull Terrier

Where do they sleep?
in his own bed

Favourite things
his mum & loads of cuddles

Most dislikes
his ears being played with
& loud noises

Favourite place
lying beside his mum
& best pal Stefan

Favourite drink
cold water

When not in pub likes to
run about with Jasmin at the park.
Also sleeping.

Cats?
he likes cats – he lives with one

Best trick
jumping up & giving paw

Favourite toy
anything that's chewable

Favourite treat
anything that's not his dinner

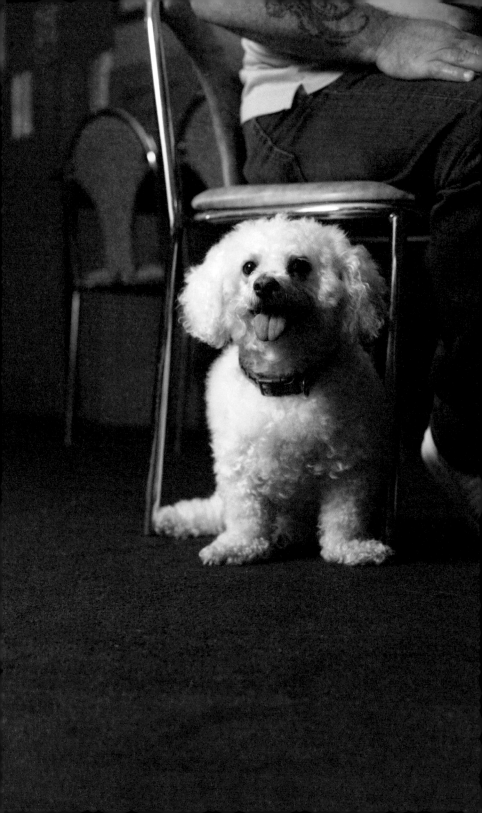

CHICO

Bichon Frisé

THE LAMPOST

Where do they sleep?
in our bedroom

When not in pub likes to
go out to the park

Favourite things
toy cat

Cats?
not bothered

Most dislikes
postman

Best trick
standing on back legs dancing

Favourite place
Hoggie loch

Favourite toy
playing catch

Favourite drink
milk

Favourite treat
bones

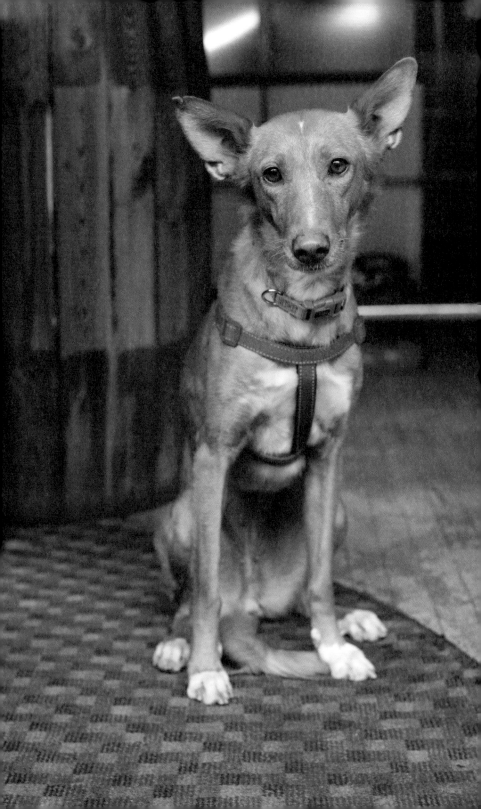

RIPLEY

13TH NOTE

Canary Islands Hound

Where do they sleep?
anywhere she can

Favourite things
long walks somewhere with
lots of trees & open spaces so
she can dash around at full speed.
Belly rubs & sleeping, too.

Most dislikes
walks in the rain, not being allowed
to chase squirrels or birds

Favourite place
Chatelherault Park in Hamilton

Favourite drink
water

When not in pub likes to
sleep, a lot!

Cats?
she'd happily get along with ours,
but the cats aren't keen

Best trick
8am wake-up call every morning
(working in a bar means 12 noon
is usually an 'early rise')

Favourite toy
a mangled rubber ball she's
half-chewed to pieces

Favourite treat
ham

The Ubiquitous Chip

BYRES ROAD

The Sparkle Horse

Thornwood Bar

The Three Judges

DUMBARTON ROAD

Bar Gallus

Brewdog

Dukes Bar

GREAT WESTERN ROAD

UNIVERSITY AVENUE

Stravaigin

Inn Deep

The Left Bank

RIVER KELVIN

KELVIN WAY

KELVINGROVE PARK

Firebird

Distill

Big Slope

Kelvingrove Cafe

The Grove

The 78

The Ben Nevis

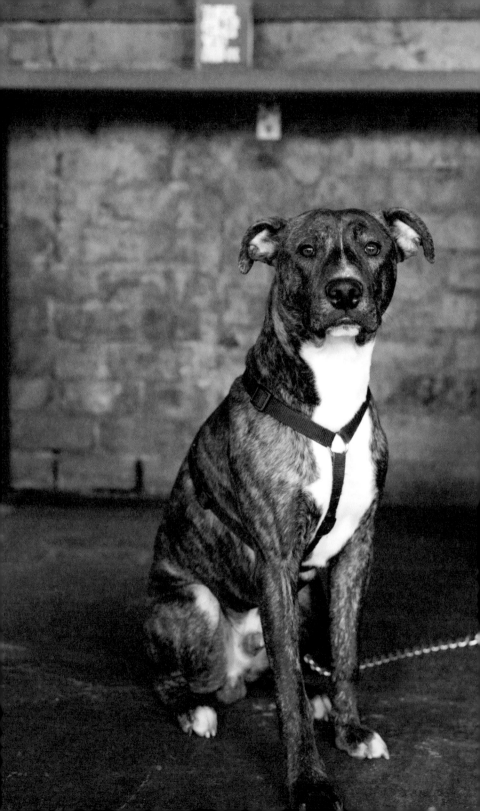

BOSSON BREWDOG

Mixed

Where do they sleep?
in his bed

When not in pub likes to
go out a walk

Favourite things
his rope toy

Cats?
likes

Most dislikes
flies

Best trick
rollover

Favourite place
the park

Favourite toy
rope

Favourite drink
water

Favourite treat
Meaty Treats

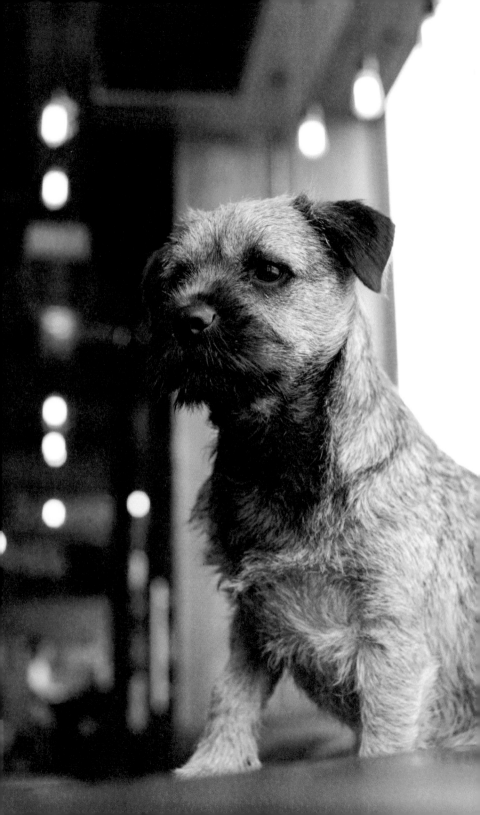

TED

Border Terrier

BREWDOG

Where do they sleep?
in owner's bed or own bed

Favourite things
he's football crazy! Chasing birds.

Most dislikes
left alone

Favourite place
any parks (Gleniffer Park)

Favourite drink
water & a sneaky lick of my wine!

When not in pub likes to
people watch & dog watch, play
with other dogs

Cats?
curious about cats & foxes

Best trick
standing on two legs

Favourite toy
squeaky soft beef burger

Favourite treat
Bakers meaty bites

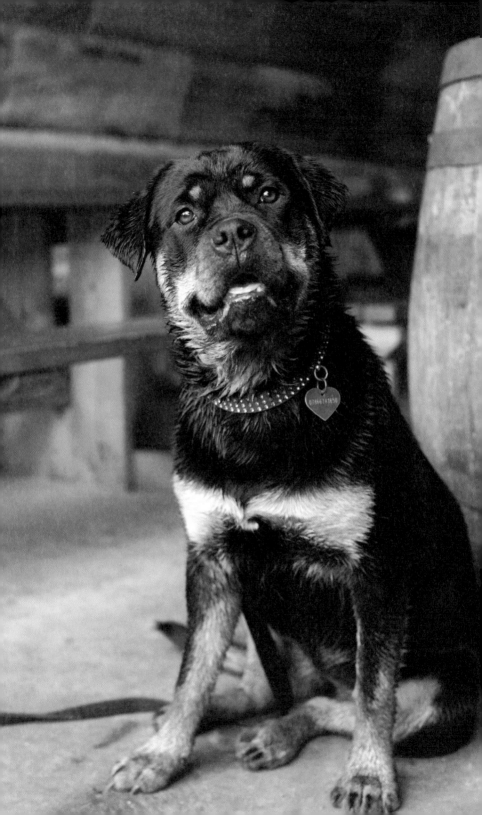

POPPY

INN DEEP

Rottweiler

Poppy's Appeal

Hello.
I'm Poppy.

Do you like my pretty collar
and my happy big face?

I'm afraid of scary dogs.
Teeth and growling
and ripping and snapping.

I've heard some High Ones say
that I'm a scary dog myself
but they don't know anything.
They don't know the real me.

Try and understand.

I'm a pussycat Rottweiler!
I'm a female in touch
with her feminine side.

I'm sensitive.
I like poetry
and butterflies and love.
I love the world. I love you.

I love my pink heart name tag
and I hope you do too.
I hope you won't laugh.

If I catch you laughing
I'll tear your throat out.

POPPY

Where do they sleep?
on my bed!

Favourite things
footballs

Most dislikes
big scary dogs!

Favourite place
Kelvingrove Park

When not in pub likes to
paddle in the Kelvin

Cats?
loves her two cats

Best trick
stealing footballs

Favourite toy
footballs!

Favourite treat
anything & everything

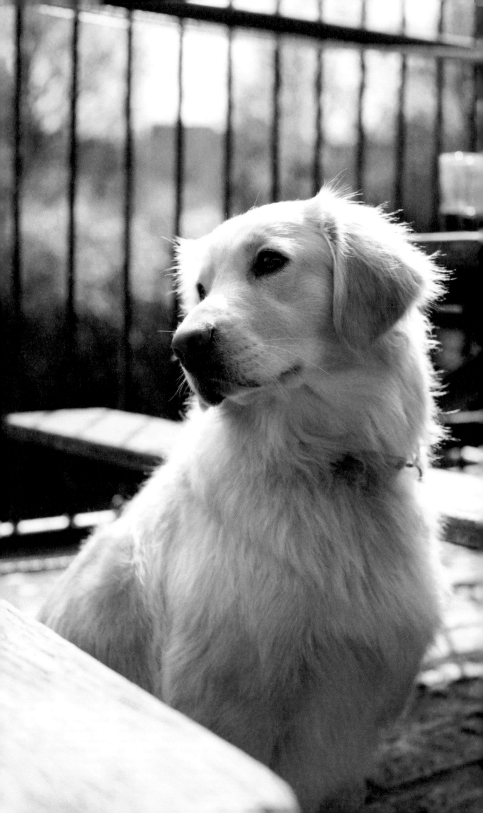

DAISY

INN DEEP

Golden Retriever

Where do they sleep?
on the sofa

Favourite things
people. Food. People. Food.

Most dislikes
nothing

Favourite place
swimming in Loch Lomond

Favourite drink
Loch Lomond

When not in pub likes to
play fight & sprint, crazily,
through boggy marshes

Cats?
likes (loves)

Best trick
making everyone love her

Favourite toy
woolly clock

Favourite treat
Paddywhack

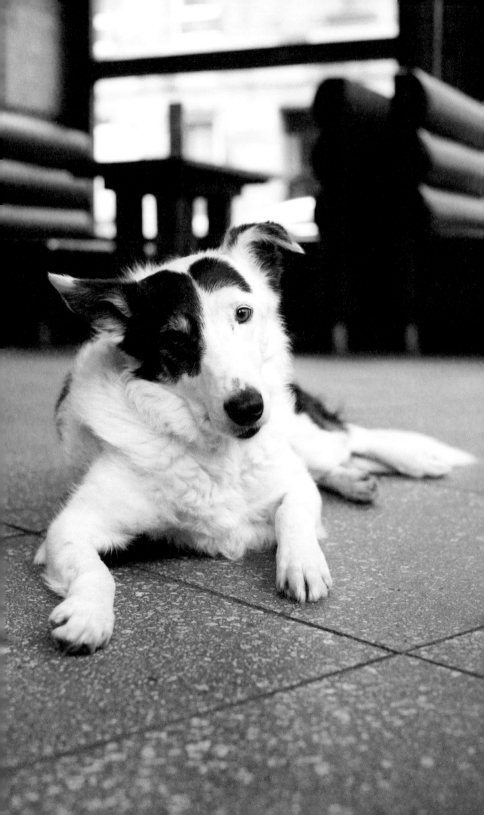

JESS

Collie Cross

FIREBIRD

Where do they sleep?
at home in one of her many beds

When not in pub likes to
stalk squirrels

Favourite things
watching for squirrels

Cats?
likes

Most dislikes
lorries, buses & fireworks

Best trick
crawling

Favourite place
Kelvingrove Park

Favourite toy
chew sticks

Favourite drink
rain water

Favourite treat
any food, especially chicken

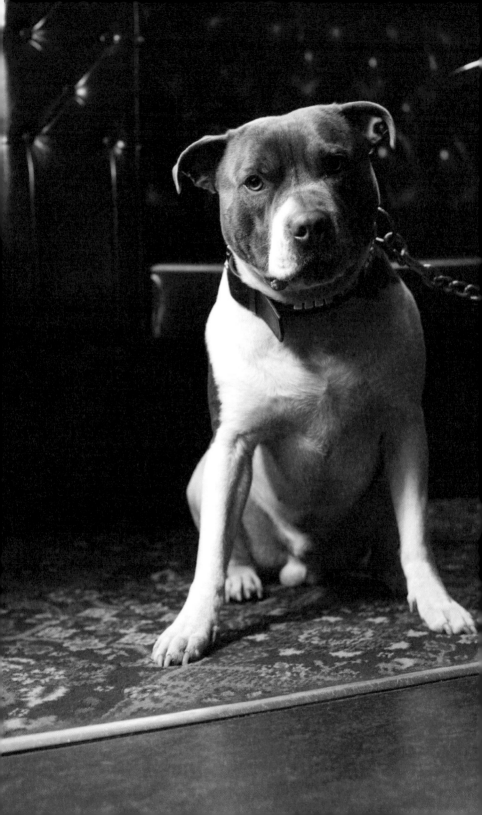

CHARLIE

THE GROVE

Staffordshire Bull Terrier

Charlie's Chain

I'm a connoisseur of movies.
Kubrick, Kurosawa, Tarkovsky.

Turner and Hooch made me puke
and I couldn't stand The Artist.
Uggie looking cute
as he dances around on
his hind legs
giving dogs a bad name.

I'm particularly fond of
the work of Tarantino.
Reservoir Dogs is my favourite
even though there isn't
a single dog in the whole film.

I'd look cool in shades,
stepping down the street with
Harvey Keitel.

I also like
Pup Fiction and Django Unchained.

I wish someone would unchain me.

I'd pay a visit to Uggie
in the Hollywood Hills
and play him my copy
of Stuck in the Middle With You.

Heeeere's Charlie!

Let's see him look cute
with his ears bitten off.
Aye, let's see him look cute
with no face.

CHARLIE

Where do they sleep?
anywhere – including bedrooms
if we forget to close the doors

Favourite things
people, pubs & parks

Most dislikes
luggage trolleys, skateboards,
hoovers, hairdryers, door bell,
rain, wind & closing time

Favourite place
on the couch with us watching
a Sunday movie

Favourite drink
Furstenberg & puddles

When not in pub likes to
find another pub & new people

Cats?
loathes

Best trick
pretending to be intelligent

Favourite toy
car tyre

Favourite treat
a fresh butcher's bone on a Friday

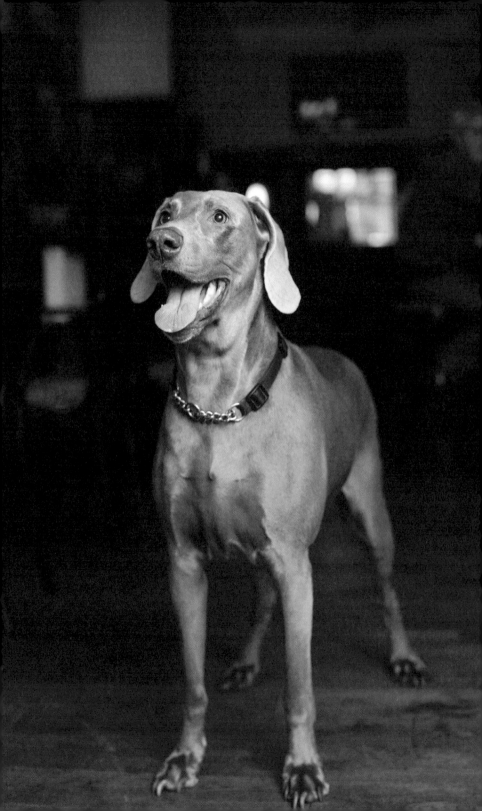

BOUNDA

THORNWOOD BAR

Weimaraner

Where do they sleep?
in bed

Favourite things
loves going in car for a drive,
has to sit in front

Most dislikes
seagulls

Favourite place
park, home & bed. Pub.

Favourite drink
tea. Coffee.

When not in pub likes to
chases the cat about wanting to
play or lays with quilt & a pillow

Cats?
loves cats. Lives with one
& loves her treats.

Best trick
likes giving high fives, loves singing
to Godfather tune on phone

Favourite toy
Kong, the cat's mouse

Favourite treat
cat treats & Jumbones

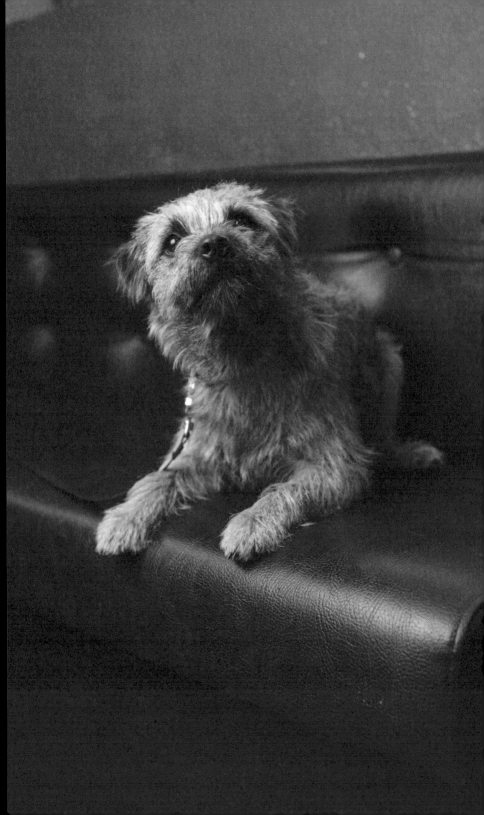

STAN

Border Terrier

DISTILL

Where do they sleep?
at the end of the bed

Favourite things
Leon the cat

Most dislikes
salad

Favourite place
Kelvingrove Park

Favourite drink
G&T (but water is also fine,
especially from the toilet)

When not in pub likes to
play in the park with pals

Cats?
LOVES!

Best trick
jumping up high for sticks

Favourite toy
squeaky ball (that he sings
along with)

Favourite treat
dental sticks

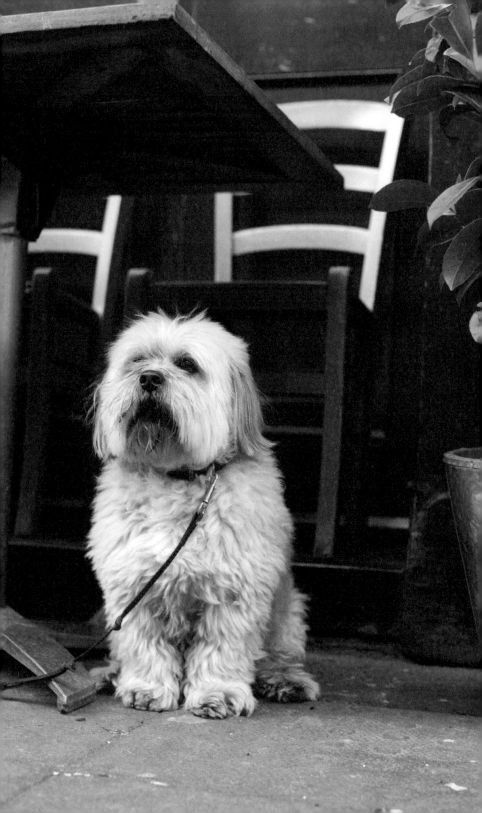

RUFUS

Lahsa Apso

STRAVAIGIN

Where do they sleep?
on my bed

Favourite things
my dinner & getting his
head scratched

Most dislikes
dog food

Favourite place
coldest place in house

Favourite drink
water

When not in pub likes to
annoy other dogs

Cats?
scared of cats

Best trick
paw

Favourite toy
bit of rope

Favourite treat
Bonos or Schamks

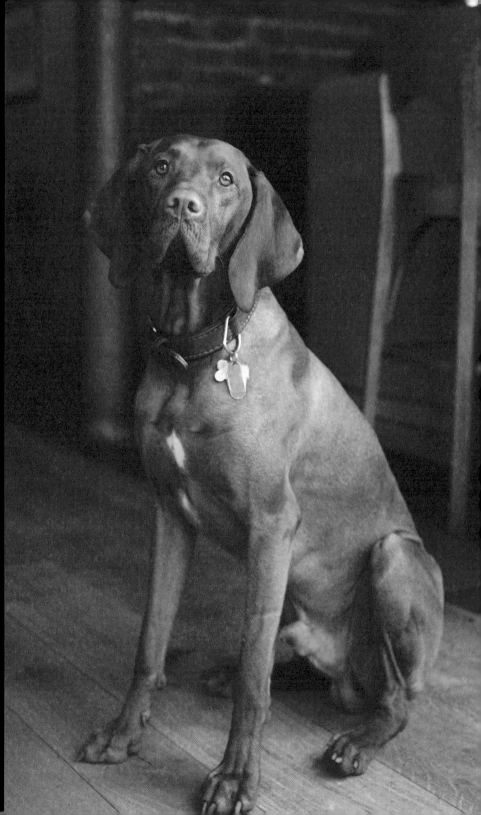

SYD

Hungarian Viszla

THE LEFT BANK

Where do they sleep?
in my bed

Favourite things
eating, playing with my pals
in the park

Most dislikes
cats

Favourite place
the Botanic Gardens

Favourite drink
when not in pub likes to
chase other dogs

Cats?
loathes some

Best trick
ball

Favourite toy
squeaking turkey

Favourite treat
biscuits, pig's ears

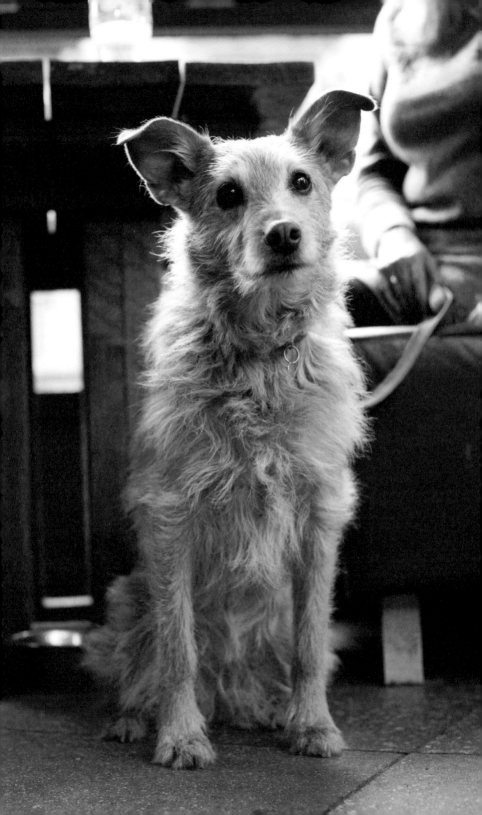

BRAN

FIREBIRD

Mixed

Bran's Ears

I've earned my rest.

I'm only listening
for myself now.

Noises sound
the same, perhaps
 a little
further away.
 A little
less important.

The phone.
The doorbell.
The television in the corner.
The rain.
The birds.
The breathing of my mistress.

My own breathing.

I've done my bit.
I've done my best.

Silence is amplified,
perhaps
 a little
closer.
 A little
more welcome.

BRAN

Where do they sleep?
in my bedroom – bran has
her own bed

Favourite things
chicken, cheese, Baker's dry
food & wet food

Most dislikes
to be told off

Favourite place
Queen's Park & other parks,
but most of all – HOME!

Favourite drink
water

When not in pub likes to
socialise with people & sleeping

Cats?
interested but frightens
if cat hisses

Best trick
she is a retired hearing dog
for deaf people

Favourite toy
ball

Favourite treat
chocs, doggie biscuits

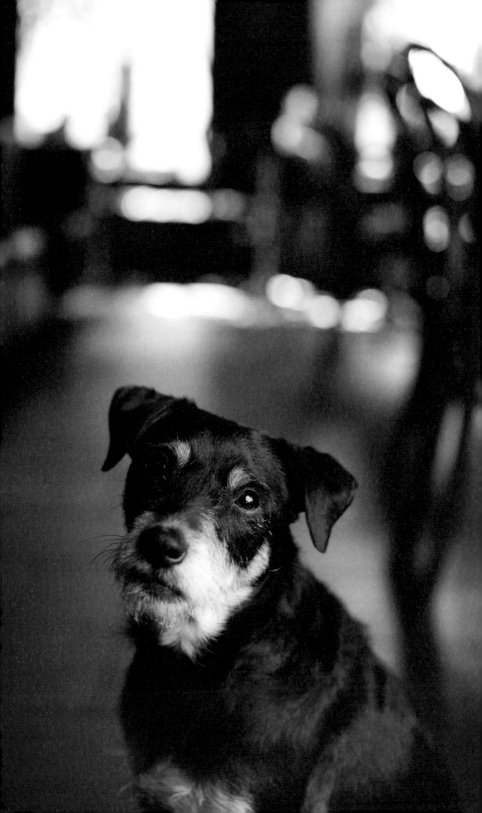

MOLLY

Terrier Cross

BIG SLOPE

Where do they sleep?
on my bed

Favourite things
tennis balls & chasing squirrels

Most dislikes
skateboards & BMXs

Favourite place
the park, the pub, the tearoom at work, & anywhere else she gets lots of attention & gets spoilt

Favourite drink
if she gets the chance, beer – I have to watch her with unattended pints in the pub

When not in pub likes to
play with her tennis ball. Play with her friends in the park.

Cats?
likes to chase them!

Best trick
learning new things for appearing in the auction catalogues at work – so far the best are probably playing the piano & playing snooker (after a fashion!)

Favourite toy
tennis ball

Favourite treat
pigs' ears

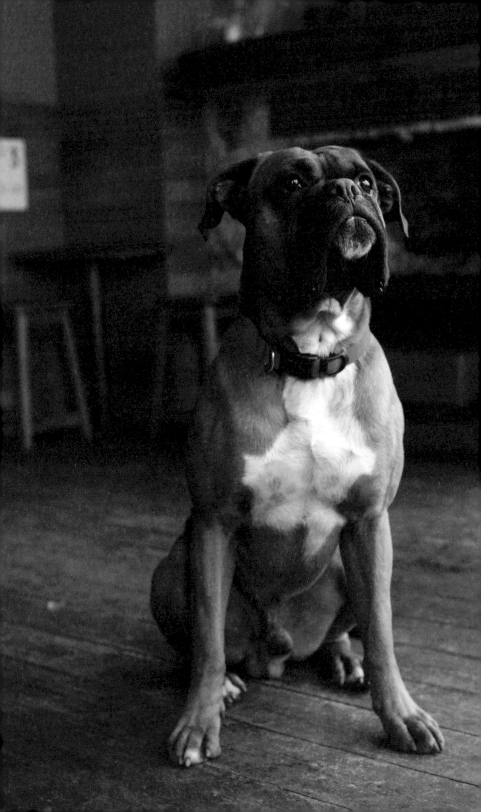

ALFIE

DUKES BAR

Boxer

Where do they sleep?
anywhere he likes

Favourite things
outdoors playing with pals, long walks – nicknamed 'Braveheart'; he loves playing but spooks easily

Most dislikes
awnings – anything that flaps about & leaving anywhere he's having fun – puts on sad face

Favourite place
beach – seaside, anywhere there's fun

Favourite drink
water

When not in pub likes to
be outside playing

Cats?
he thinks they are dogs – so likes them – they don't like him

Best trick
finding balls – problem solving

Favourite toy
ball on rope

Favourite treat
mackerel

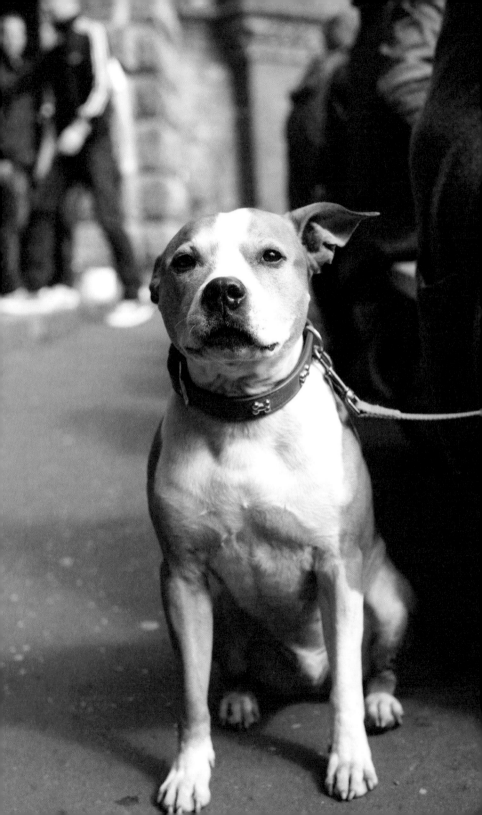

TY

Staffie Cross

INN DEEP

Where do they sleep?
cage

When not in pub likes to
sleep

Favourite things
his ball, cuddly toys, bits of rope

Cats?
likes cats

Most dislikes
bath time

Best trick
high five

Favourite place
the beach

Favourite toy
his ball

Favourite drink
water – he's a sober boy!

Favourite treat
Jumbone

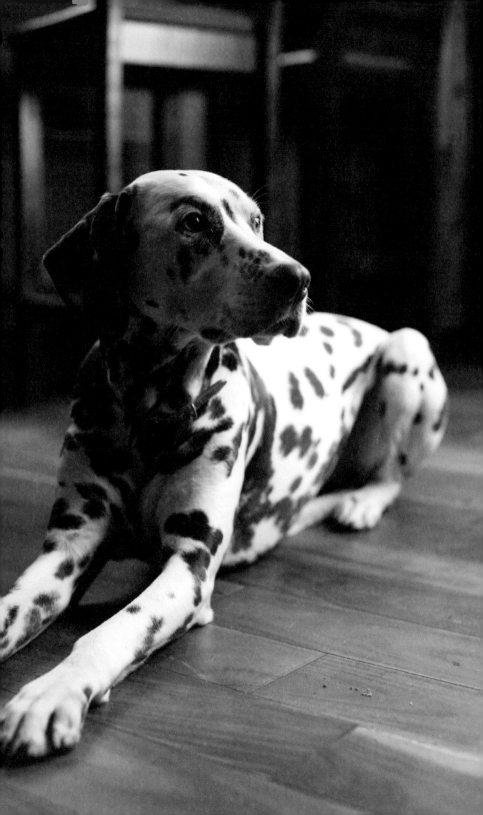

POPPY

Dalmatian

THE THREE JUDGES

Where do they sleep?
doggy bed at home & garage floor

Favourite things
treats, running, playing with
Juno the Labrador, backscratching

Most dislikes
lettuce, sudden noises
like fireworks

Favourite place
The Three Judges & its owner's
garage

Favourite drink
Guinness with ice cubes, but not
too much. Water.

When not in pub likes to
go camping & fishing, eating the
mackerel when I catch them

Cats?
likes to chase cats just for a laugh;
there's no fighting. Likes to bark at
motorcycles & push bikes.

Best trick
ask for a treat. Almost talks.

Favourite toy
football

Favourite treat
pigs' ears & prawn crackers
(Chinese)

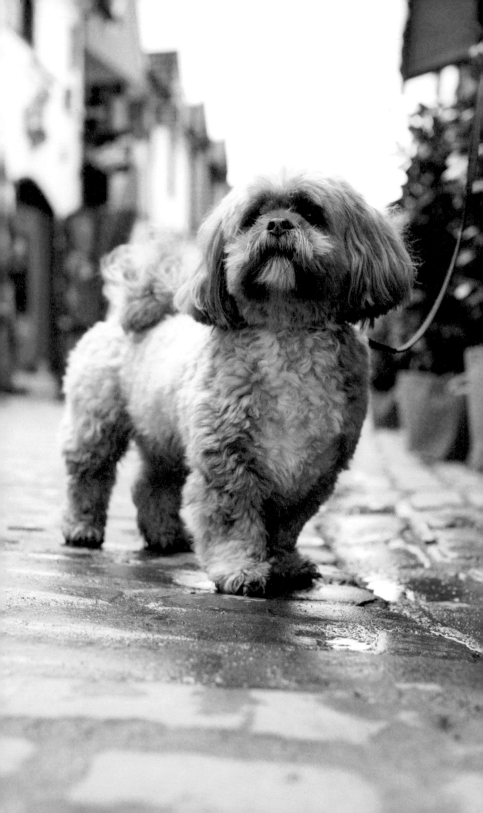

TRIXIE

Lhasa Apso

UBIQUITOUS CHIP

Where do they sleep?
on my bed!

Favourite things
squeaky toys & being inside comfy
& warm when wet outside, Troon
beach, rolling in seaweed

Most dislikes
sitting in the wet & photoshoots,
being treated like a dog

Favourite place
Troon beach, Botanics

Favourite drink
water

When not in pub likes to
be made a fuss of by everyone!

Cats?
bemused by them

Best trick
lies down & lifts her paw when
wants her belly rubbed

Favourite toy
squeaky fluffy toy

Favourite treat
salmon

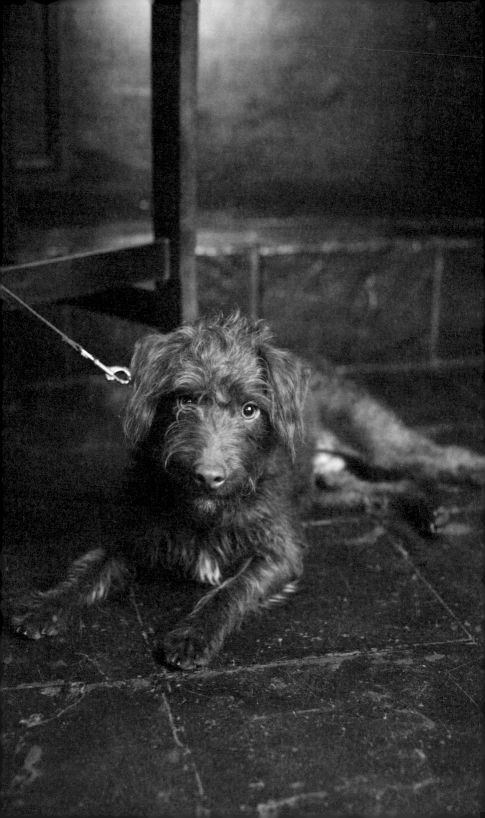

ARTHUR

Patterdale

THE THREE JUDGES

Where do they sleep?
on the back of our couch

Favourite things
playing out in the park and
chasing the birds

Most dislikes
other dogs

Favourite place
out in the country going for walks

Favourite drink
cold bowl of water

When not in pub likes to
out as much as possible

Cats?
likes some

Best trick
jumping up high to catch
his toy ball

Favourite toy
chicken squeezy

Favourite treat
chocolate buttons (now and then)

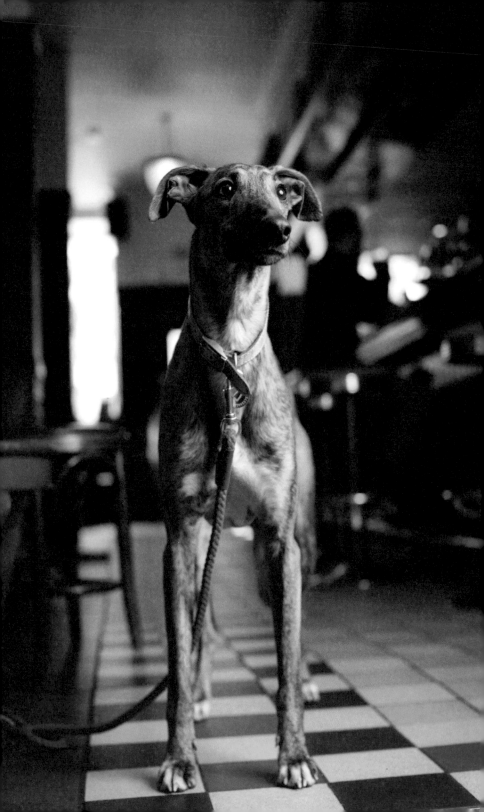

FRANK

Lurcher

THE SPARKLE HORSE

Where do they sleep?
Frank's favourite place to sleep is
in bed. He doesn't care who with.

Favourite things
pigs' ears, chasing squirrels,
jamming his nose into
people's crotches

Most dislikes
baths, foxes, cats, being left
on his own

Favourite place
wide open spaces where he
can run. The beach is the best.

Favourite drink
milk

When not in pub likes to
run & sleep

Cats?
likes them as people but wants to
play/chase/harass them for fun

Best trick
returning the ball to between
your legs/crotch

Favourite toy
ball & launcher

Favourite treat
pigs' ears

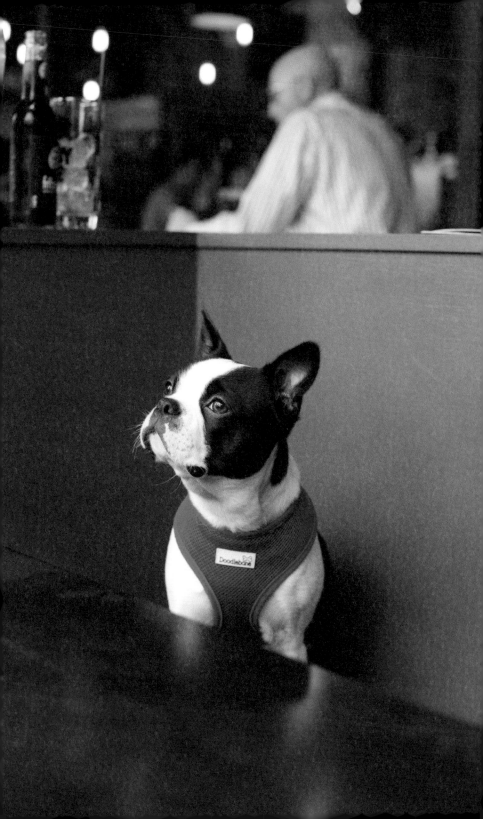

CISCO

Boston Terrier

BREWDOG

Where do they sleep?
living room or anywhere comfy

Favourite things
love chips, fluffy sheep & chasing
balls, also likes to roll in seaweed

Most dislikes
beer & coffee

Favourite place
Queen's Park & Saltcoats beach

Favourite drink
water (likes milk but gets an
upset tummy)

When not in pub likes to
eat & sleep

Cats?
likes cats, likes everything!

Best trick
high five – ringing a bell for treats
(video on Instagram)

Favourite toy
squeaky pig & sheep to go
to sleep with

Favourite treat
anything, he's greedy! Others feed
him chips or he gets them off the
bar floor.

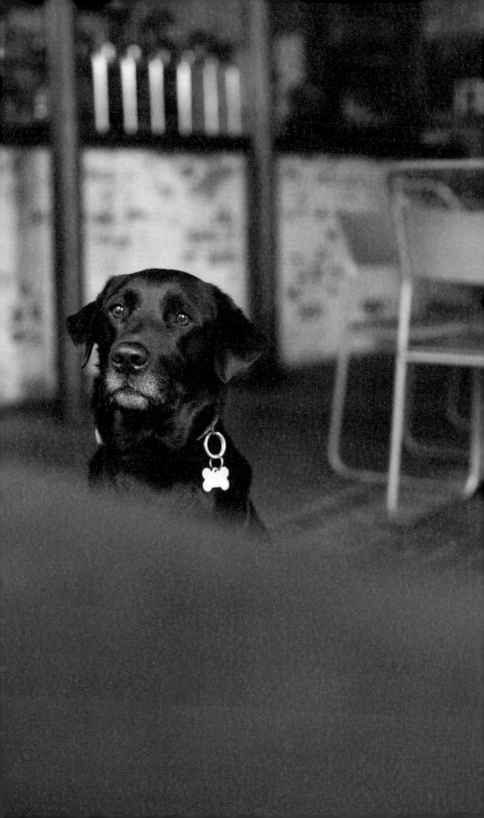

KAYA

DUKES BAR

Black Labrador

Where do they sleep?
Kaya's bed is in the living room, she sleeps there when we're watching. When we're not, she sleeps in a variety of places she's not supposed to (bed, chairs, behind curtains).

Favourite things
cuddles, tennis balls, floor chips, belly rubs, being blow-dried, swimming, licking people's faces, the doorstop at Dukes

Most dislikes
the washing machine & the wind making doors bang

Favourite drink
every puddle. She also loves it when you squirt water from a bottle into her mouth, but it's not a very efficient means of hydration.

When not in pub likes to
lick herself noisily. Run in the park with her friends, & swim in the Kelvin. She likes a good game of 'tug', but has trouble letting you get close enough.

Cats?
she's never gotten close enough to make an objective decision. She's more of a fox girl, to be honest.

Best trick
her best actual trick is a high-five, which she'll do for food. Other than that, she can open doors – but only when the washing machine's on & she wants to get into my bed.

Favourite toy
the doorstep at Dukes. Or her teddy, which is fairly disgusting these days

Favourite treat
anything she's not supposed to have

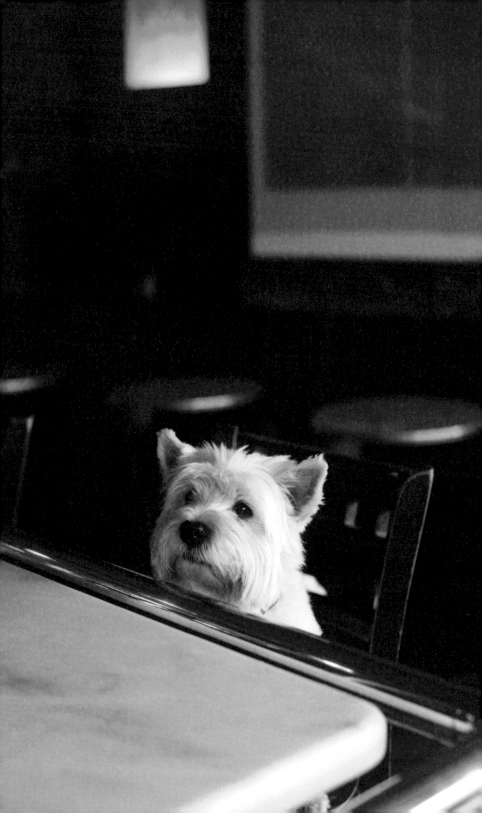

BENNET

KELVINGROVE CAFÉ

West Highland Terrier

Where do they sleep?
in my bed, often on my cushion

Favourite things
me & his foster dad Danny.
His pink elephant teddy & scran.

Most dislikes
his wee cousin, Broadie – they are
not pals at all. He's managed to pin
him up against a wall in the past.

Favourite place
any park he hasn't previously
been bullied or bammed up by
other dogs in

Favourite drink
I think he would drink ale,
if he could

When not in pub likes to
trying to make pals in the park/
street. Awful at it though, other
dogs are rarely into hanging out
with him. He is mad dumb.

Cats?
loathes

Best trick
he's mad daft, he can offer his
left paw up for treats

Favourite toy
a pink elephant

Favourite treat
hanging out in Distill

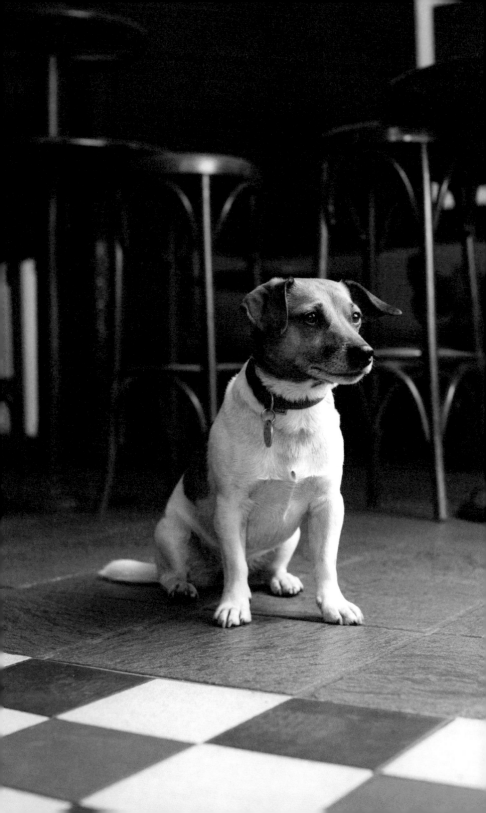

CANNA

THE SPARKLE HORSE

Jack Russell

Where do they sleep?
with Lola

Favourite things
the big dogs, squirrel chasing,
beach walks

Most dislikes
being left behind

Favourite place
top of Munroe or beach

Favourite drink
puddles

When not in pub likes to
chase tennis balls

Cats?
likes cats

Best trick
standing on back legs

Favourite toy
green snake

Favourite treat
sausages

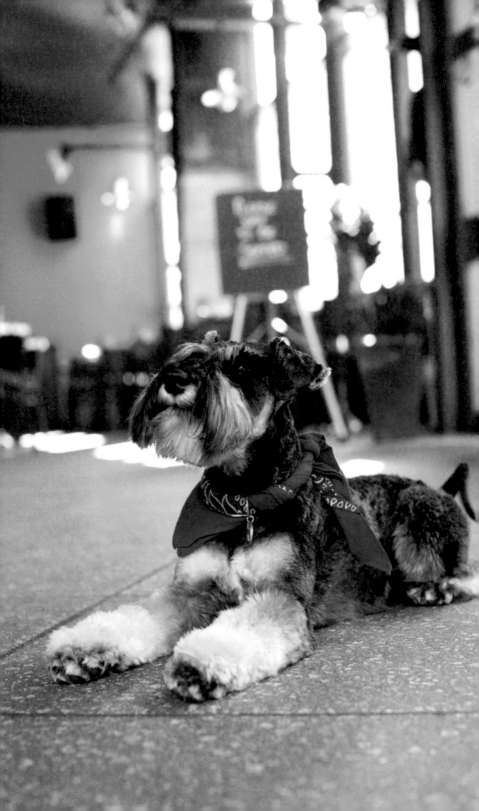

HECTOR

FIREBIRD

Schnauzer

Hector's Hold-up

Yeehaa!
I'm Wild Hector Hickok,
the six-shooting Schnauzer,
a.k.a.
Butch Hector, the Schnauzer Kid.

Fastest pooch in the West
(of Glasgow).
The boneslinger of Kelvingrove.

This is a nice saloon.
It's way past High Noon
so give me a shot of red eye,
and if you don't have any red eye
then give me a G&T.

How do you like my bandit mask
and my Wyatt Earp moustache?
How do you like my red bandana
and my snug fluffy chaps?

I wear them on all of my jobs.

I wear them when I terrorise
the jakies and junkies
on Byres Road,
the beggars in the doorways.
I wear them when I rob
the BIG ISSUE salesmen.

This is a hold-up!
Hand over all your fish bites!

HECTOR

Where do they sleep?
in bedroom (own bed), at night
with me

Favourite things
his tug toy & ball, getting dried
with the hair dryer

Favourite place
Kelvingrove Park

Favourite drink
water but a Hendricks gin & tonic
if you're buying

Cats?
don't know

Best trick
walking on his hind legs

Favourite toy
Kong tug toy

Favourite treat
fish bites (dried fish)

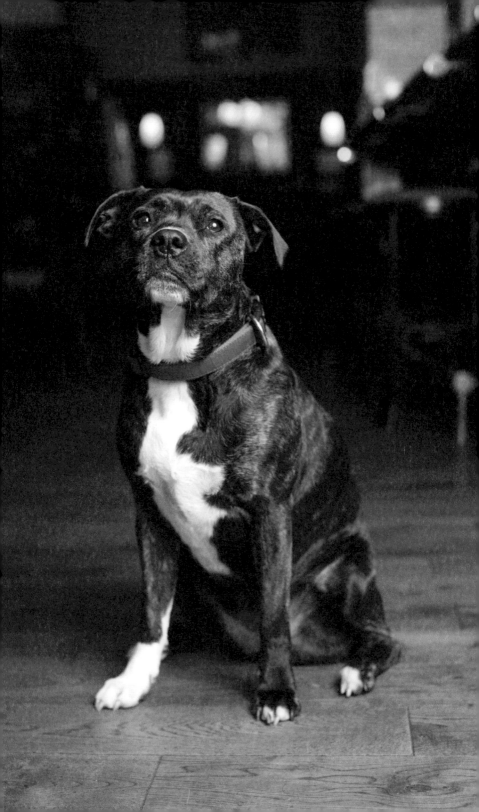

ROXANNE

THORNWOOD BAR

Staffie Cross

Where do they sleep?
loves her bed

Favourite things
her ball

Most dislikes
hoover – she attacks it

Favourite place
out in the sun

Favourite drink
only water

When not in pub likes to
sleep – she's the laziest dog
I've evet met

Cats?
love my mums cat, Zinc

Best trick
not much of a trick, but she sounds
like a cat when she yawns

Favourite toy
ball

Favourite treat
pigs' ears

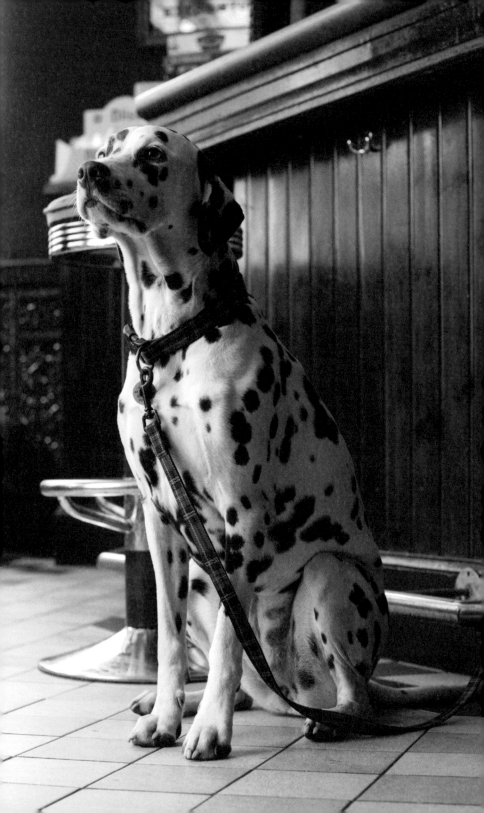

LOLA

Dalmatian

THE SPARKLE HORSE

Where do they sleep?
in a pink tent

Favourite things
food

Most dislikes
bath

Favourite place
my bed

Favourite drink
milk

When not in pub likes to
mountain bike or play with
the big dogs

Cats?
loves to chase cats

Best trick
giving a paw unasked in an
attempt to secure food

Favourite toy
whatever toy 'Frank' (Lurcher)
is playing with

Favourite treat
venison sausages

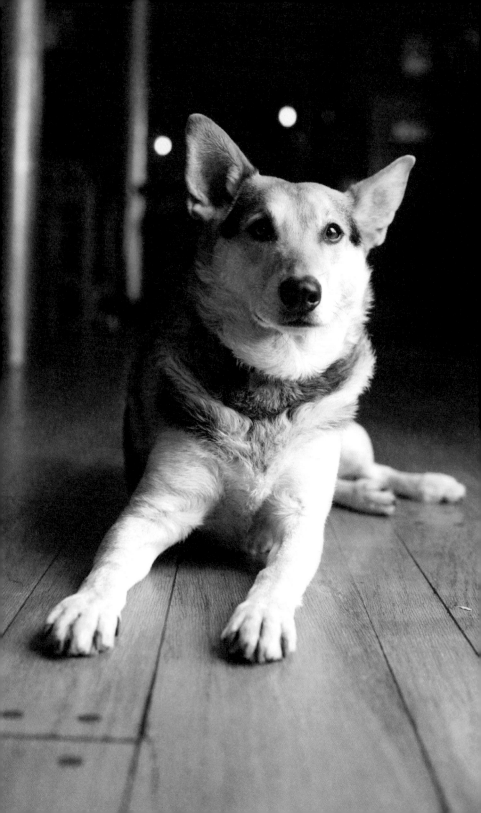

TOMMY

BAR GALLUS

Alsatian & Collie Cross

Where do they sleep?
everywhere

When not in pub likes to
go dancing

Favourite things
food, people, girls & doormats

Cats?
jury is out

Most dislikes
black cabs

Best trick
roll over play dead on command

Favourite place
with me

Favourite toy
rabbit

Favourite drink
water

Favourite treat
bacon

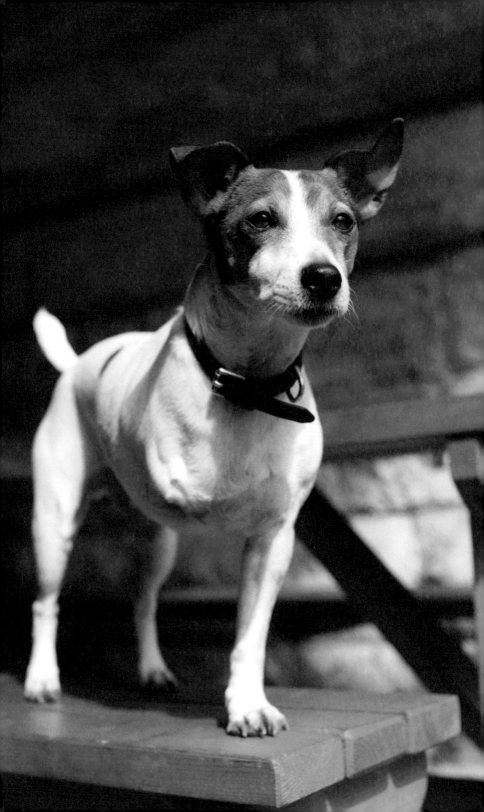

TOBY

Jack Russell

INN DEEP

Toby's Leg

Who needs four legs
 when you've
 got THREE!
I laugh at your fourth leg!
I spit in the face of your
silly fourth leg!
Three has always been stronger.
More symmetrical.
Better balance.
Father, son, holy ghost.
The Marx Brothers, without Zeppo.
The Beatles, without Ringo.
It's made me what
I am today.
Noble, handsome, resourceful.

They'll make a statue of me
and boot Greyfriars Bobby
from his plinth.
I laugh at your Greyfriars Bobby!
I spit in the face
of your East Coast mutt!
People will come
and rub the place
where the fourth leg should be.

Of course,
it'll bring me that bit closer
to the High Ones.

I've heard them say
that two legs is best.

One down, one to go.

TOBY

Where do they sleep?
comfy wee bed & any
couch available

Favourite things
sausages, people & the sun to lie in

Most dislikes
not getting a walk (very rare!)

Favourite place
the Kelvin

Favourite drink
water & occasionally a cup
of milky tea

When not in pub likes to
sleep whenever possible

Cats?
loathes!!

Best trick
socialising!

Favourite toy
tennis ball

Favourite treat
dental stick

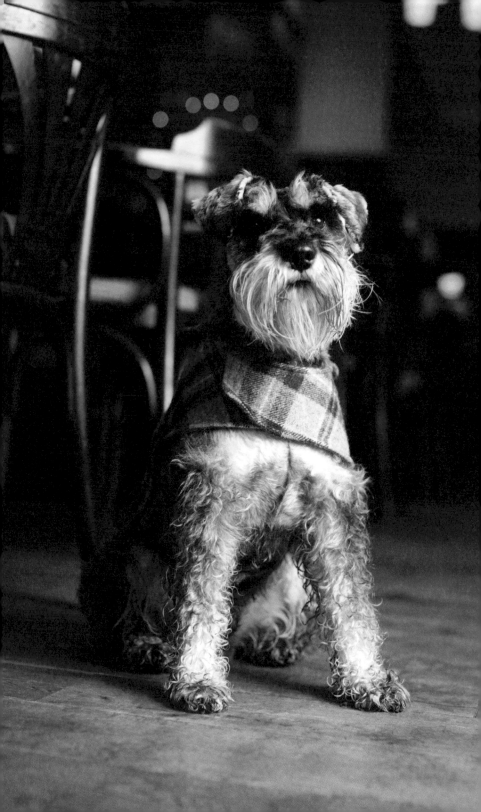

SUILVAN

THORNWOOD BAR

Mini Schnauzer

Where do they sleep?
with me

Favourite things
his "Go get it", the beach,
Victoria Park, Poppy,
his girlfriend. Hot carrots.

Most dislikes
me sneezing, freaks him out

Favourite place
Fossil Grove, Victoria Park

Favourite drink
puddles. Lake in Victoria Park.

When not in pub likes to
go to park, shop (my business),
back-yard. Beach.

Cats?
hates. Cat next door is massive
bully (ginger!)

Best trick
dancing! Loves to dance in my
arms or by himself.

Favourite toy
his "Go get it!"

Favourite treat
tickling his ears. Plus a gravy bone.

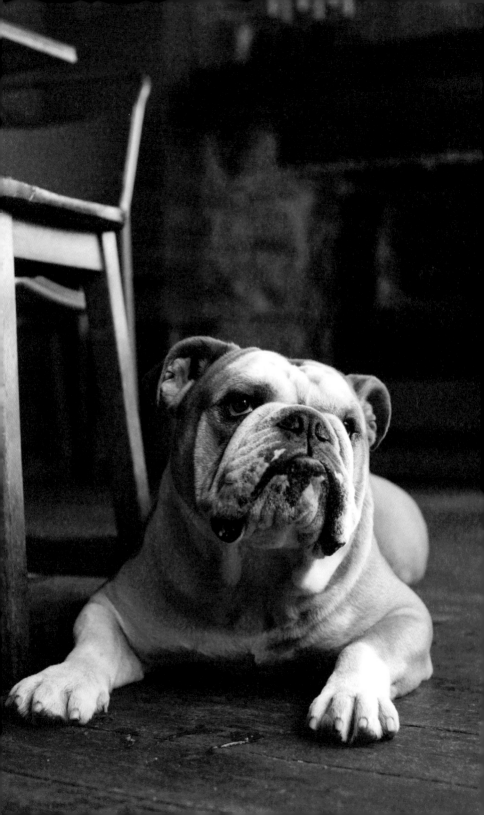

FINDLAY

DUKES BAR

Bulldog

Where do they sleep?
in bed

Favourite things
running around in the countryside

Most dislikes
foxes

Favourite place
Mugdock

Favourite drink
tea

When not in pub likes to
country side, beach,
watching Crufts

Cats?
likes cats, we have two:
Anya & Magda

Best trick
high five

Favourite toy
bucket / yoga ball

Favourite treat
butcher's joint

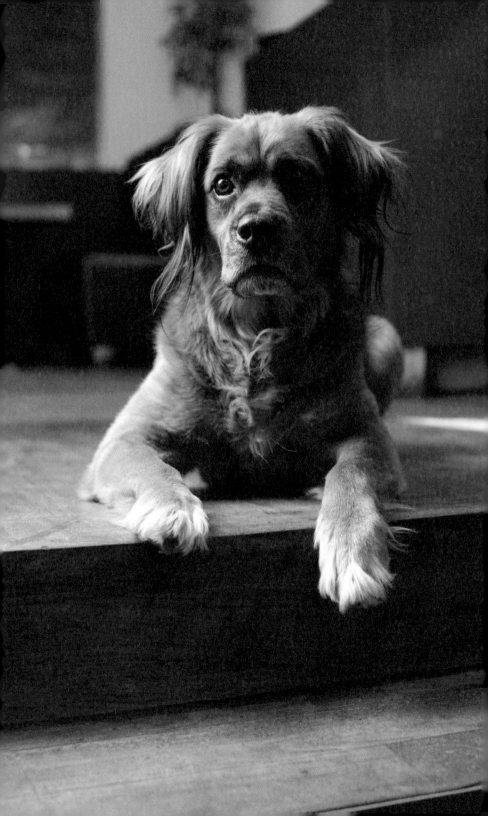

TYSON

Leonberger Cross

DISTILL

Where do they sleep?
at the end of our bed

Favourite things
riverside walks & swims in the
Kelvin, Dog treats, Sonny Boy
Williamson

Most dislikes
Alasatians, Tomato food bottles,
being on the lead

Favourite place
the park, the river

Favourite drink
milk

When not in pub likes to
hang out with his master

Cats?
likes cats

Best trick
high five

Favourite toy
squeaky pig

Favourite treat
Shmackos or Weebox

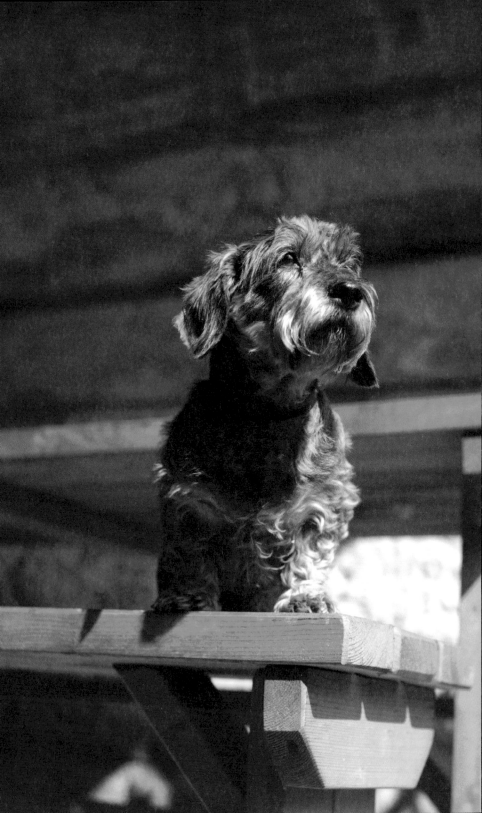

MAISY

INN DEEP

Dachshund

Where do they sleep?
comfy wee bed & any couch
available

Favourite things
sausages, people & the sun to lie in

Most dislikes
not getting a walk (very rare!)

Favourite place
the Kelvin

Favourite drink
water & occasionally a cup
of milky tea

When not in pub likes to
sleep whenever possible

Cats?
loathes!!

Best trick
socialising!

Favourite toy
tennis ball

Favourite treat
dental stick

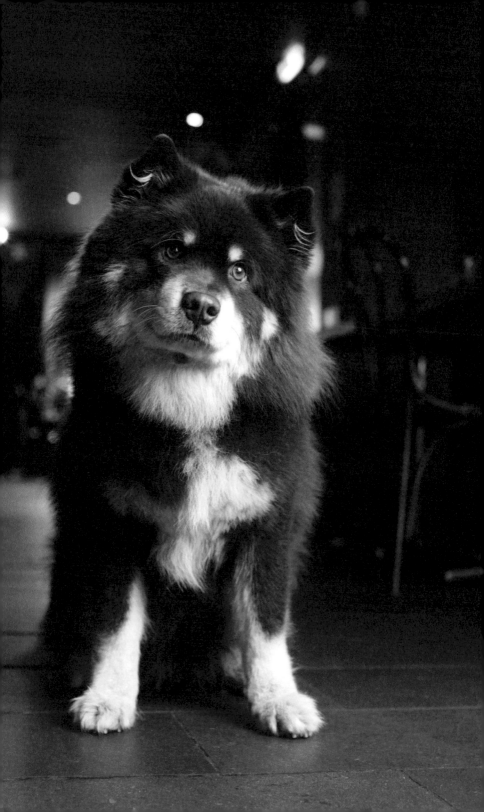

KARHU

BIG SLOPE

Finnish Lapphund

Where do they sleep?
on his windowseat overlooking the park with a nose poking out the open window.

Favourite things
tennis balls & carrots & the odd French fry from the Big Slope.

Most dislikes
blogging on Thankfifi.com

Favourite place
Elie Beach (preferably in the sea up to his elbows)

Favourite drink
water

When not in pub likes to
eat or sleep or go west end walking

Cats?
likes cats. Cats don't like him.

Best trick
dirty feet – he wipes his paws on the mat before coming into the cream carpets of our apartment

Favourite toy
tennis ball. His or not (stolen or found). In any state.

Favourite treat
Big Slope French fries

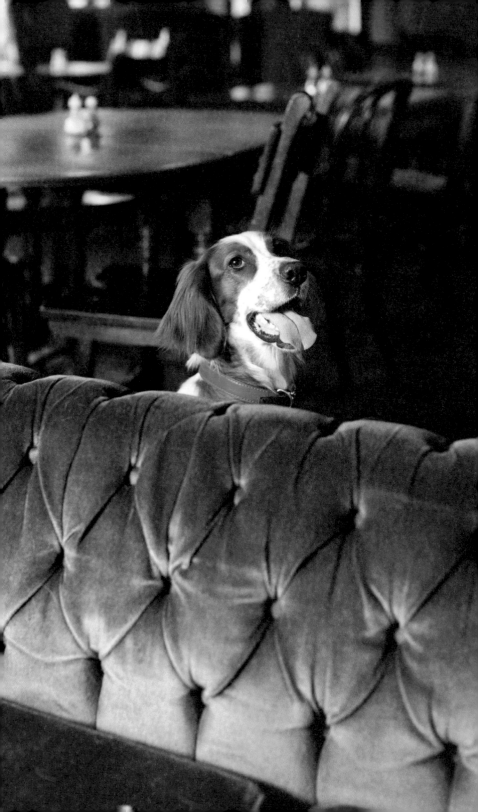

LADY

THE 78

Red & White Irish Setter

Where do they sleep?
crate in the living room,
covered in blankets

Favourite things
running, ball, cuddles, jumping,
best dog pal Lailea. Also likes
rolling in poop.

Most dislikes
scary metal noises, the hoover,
prams

Favourite place
Kelvin river park, or sleeping on
the sofa or bed

Favourite drink
water & sometimes steals sips
of tea

When not in pub likes to
throw toy parties, wrestling other
dogs, swim in river Kelvin

Cats?
loves cats (too much)

Best trick
she can high five

Favourite toy
any ball, especially if it belongs to
another dog

Favourite treat
Big Slope French fries.
She had pulled pork once & lost
her mind, but usually eats
dental sticks.

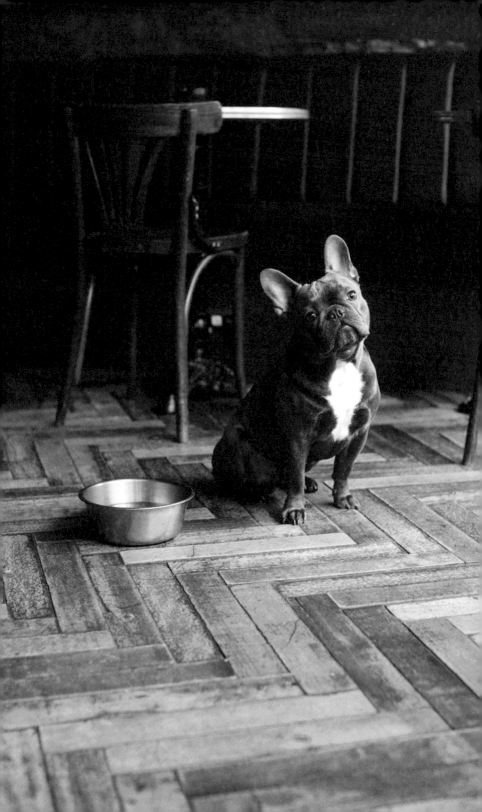

FRANÇOIS

French Bulldog

KELVINGROVE CAFE

Where do they sleep?
in his bed at the beginning of the night until probably 30 secs after I fall asleep, then he 'asks' to come into my bed. He is in & out at his own pleasure, then I will wake up with him upside down in the middle of my bed. Snoring. Wildly.

Favourite things
shoes. Make up. Sweets, empty plastic bottles. The less he is allowed it, the more he likes it. Barking at nothing, scratching his paws.

Most dislikes
bras

Favourite place
the rain

Favourite drink
an Old Fashioned. Made by his very good friends at the Kelvingrove Café.

When not in pub likes to
sleep it off

Cats?
unsure. Has not come face to face with one but has certainly tried to. Chased one down the street once.

Best trick
he can sit & give you a paw & sometimes will 'wait' if you are lucky. Most of the time, doesn't even know his own name.

Favourite toy
anything he can chew

Favourite treat
whatever you are eating

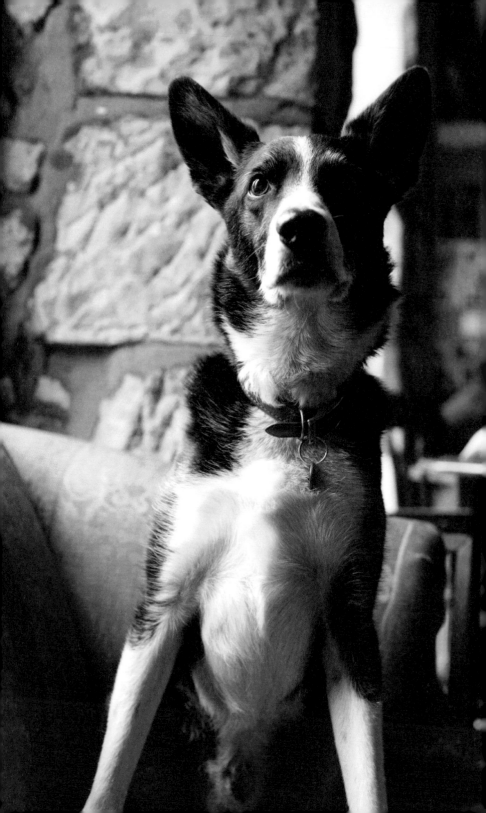

MR.SCAMPO THE 78

Border Collie

Where do they sleep?
starts off in his bed; ends up in ours

Favourite things
riding shotgun in the car, leaning
into every curve & anticipating
every pothole in the road

Most dislikes
celery, fast cyclists, fluffy lapdogs,
& the sound of metal shutters being
pulled down

Favourite place
the campsite on the Isle of Eigg:
total freedom (and no metal
shutters)

Favourite drink
likes to stick his head into
a flushing toilet & slurp

When not in pub likes to
lie in his bed & dream of being
in the pub

Cats?
he runs up aggressively to cats
then runs away like a big feartie
when they hiss & spit at him

Best trick
getting into the bin no matter
how well it is secured; or locked
in a cupboard

Favourite toy
a tiny fragment of what was once
a purple ball

Favourite treat
hoovering up scarps off the floor
of The 78; he carefully watches
families with small children

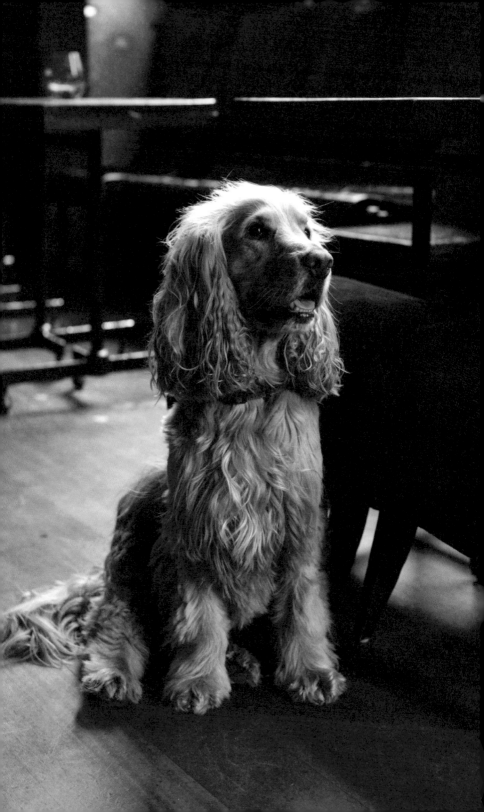

COOPER

THE BEN NEVIS

Cocker Spaniel

Where do they sleep?
whereever I lay my head,
that's my home

Favourite things
any old moggy will do me

Most dislikes
rejection

Favourite place
mine

Favourite drink
hair of the dog.

When not in pub likes to
sleep it off

Cats?
not bothered

Best trick
can't remember (snipped)

Favourite treat
happy hour

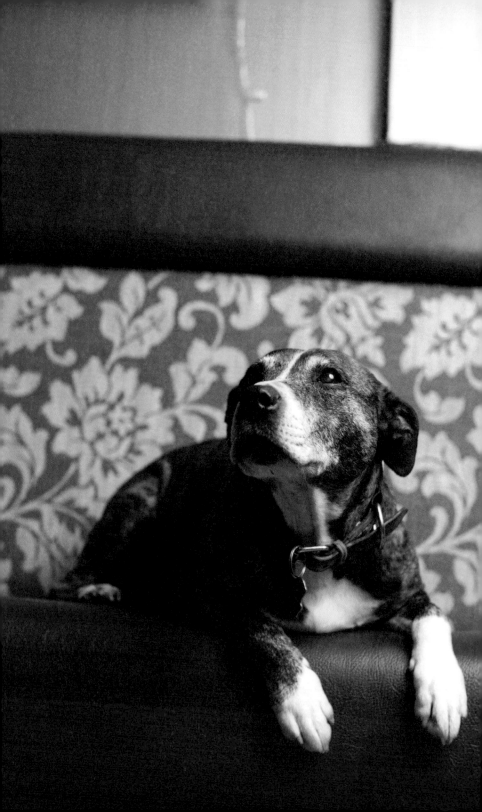

BUSTER

THORNWOOD BAR

Staffie Cross

Where do they sleep?
between my legs/on the couch

Favourite things
loves Markies, in his younger days
it was his 'kang'

Most dislikes
hates the hoover & hairdryer

Favourite place
on the couch

Favourite drink
water

When not in pub likes to
sleep, still likes to chase the ball

Cats?
scared of them, believe it or not!

Best trick
in his younger days, was
demolishing traffic cones

Favourite toy
kang

Favourite treat
Markies

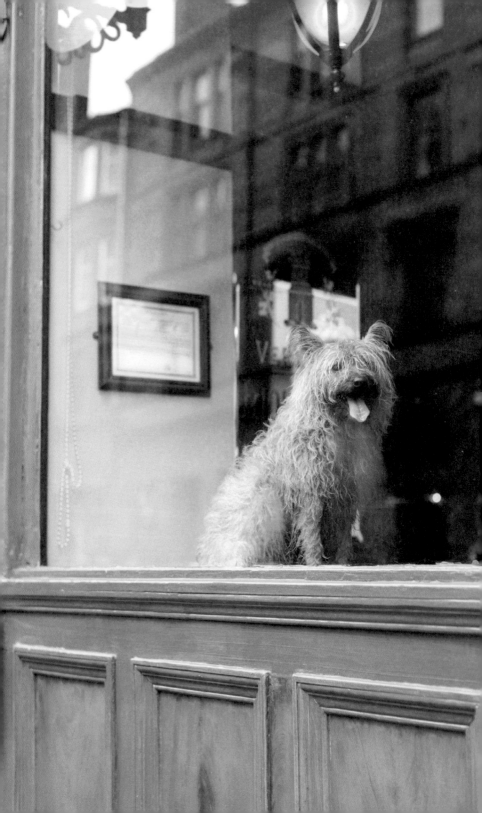

KIM

Cairn Terrier

THE THREE JUDGES

Where do they sleep?
basically anywhere,
although chair is favourite

Favourite things
running free

Most dislikes
motorbikes, Guy Fawkes

Favourite place
Kelvingrove Park,
The Three Judges

Favourite drink
lager shandy, milk, water

When not in pub likes to
go long walks

Cats?
likes

Best trick
sleeping

Favourite toy
squeaky horse

Favourite treat
prawns

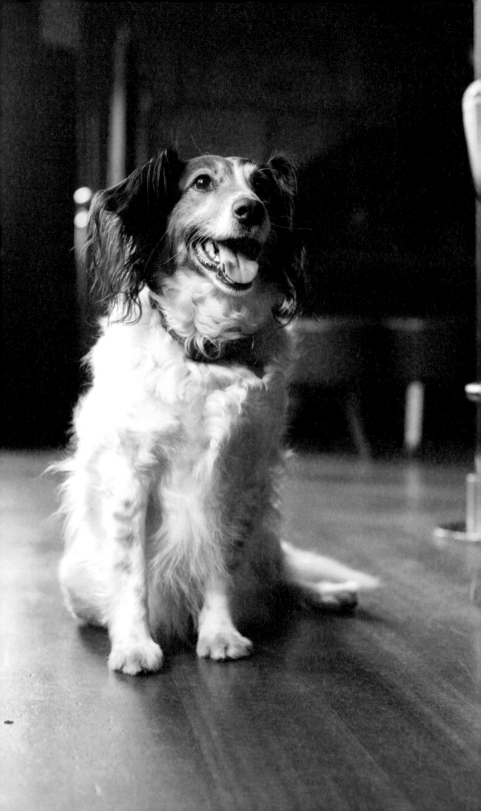

JENNY

Collie & Springer Spaniel Cross

THE BEN NEVIS

Where do they sleep?
in her bed

When not in pub likes to
play & walk & sunbathe

Favourite things
our blanket – toy

Cats?
likes cats

Most dislikes
policemen

Best trick
rolling over

Favourite place
The Braes & Troon Beach

Favourite toy
Squidgy Spider

Favourite drink
water & white wine

Favourite treat
a cuddle on the sofa

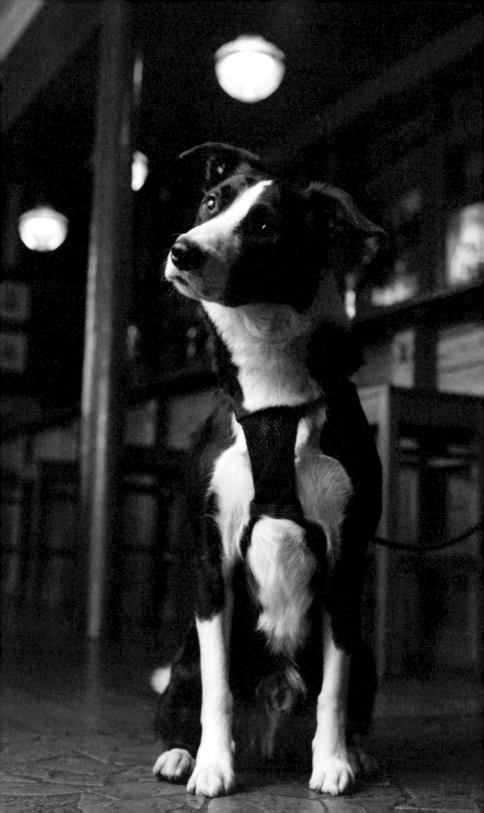

FINN

Collie Cross

BAR GALLUS

Where do they sleep?
sofa

When not in pub likes to
sleep, lick rear end, fart!

Favourite things
foxes, biscuits, motorbikes

Cats?
fears them (had a run
in with a ginger tom)

Most dislikes
Tommy the dog, large woman,
people with crutches

Best trick
scrounging

Favourite place
pub, park, Glasgow uni

Favourite toy
stuffed rabbit

Favourite drink
water, 12 year old malts

Favourite treat
smoked sausage

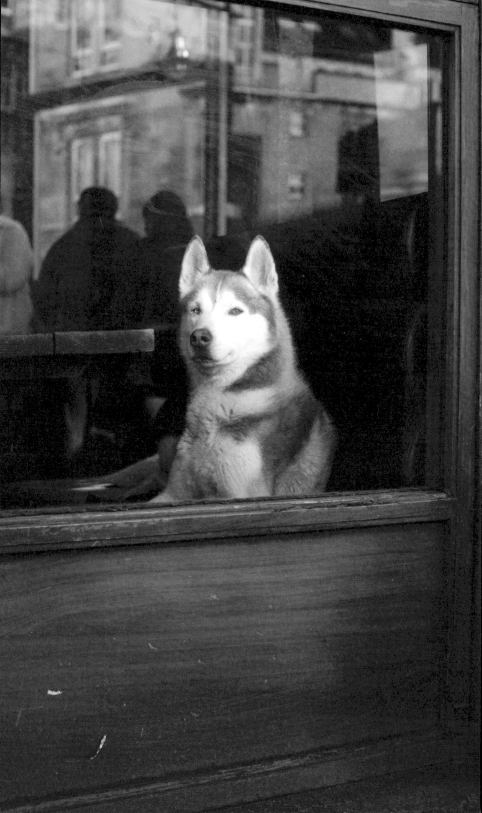

JUNO

Siberian Husky

FIREBIRD

Where do they sleep?
in his (my) bed

Favourite things
friends & walks

Most dislikes
skateboarders (the resonant
noise scares him)

Favourite place
with his human pub mates

Favourite drink
H_2O

When not in pub likes to
walk, walk, walk

cats?
very intrigued but daren't find out

Best trick
being cool

Favourite toy
too many to mention

Favourite treat
chicken

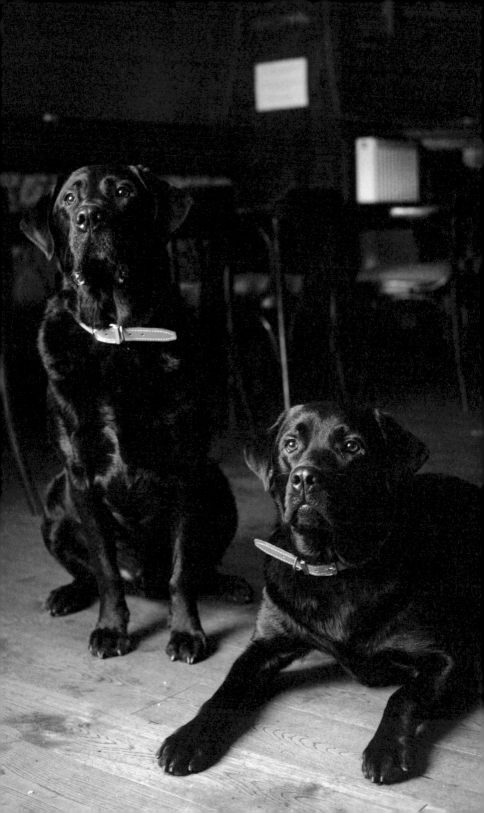

BAXTER & OSCAR

Black Lab

THORNWOOD BAR

Where do they sleep?
Baxter sleeps on our couch, even though he has a great bed. Oscar stays in his own bed, just beside his mummy.

Favourite things
Baxter adores water, from puddles to ponds (despite vicious swans!). Oscar just loves stealing things. Should have been called Fagin.

Most dislikes
Baxter hates loud bangs & Oscar absolutely loathes water

Favourite place
Baxter likes the beach, or anywhere he can be off the lead. Oscar really enjoys our holidays in the Lake District.

Favourite drink
goats' milk. For both of them.

When not in pub likes to
Baxter enjoys socialising with other dogs, whilst Oscar prefers sleep-overs at Lisa's (one of the staff at the Thornwood)

Cats?
Baxter has yet to see one, but Oscar hates them

Best trick
Baxter – turning beer mats into 100,000 pieces. Oscar – kissing with no tongues.

Favourite toy
Baxter treasures his cheeky monkey, whereas Oscar is happy with a scarf – it doesn't matter whose

Favourite treat
Baxter will have anything, but Oscar likes a gravy bone

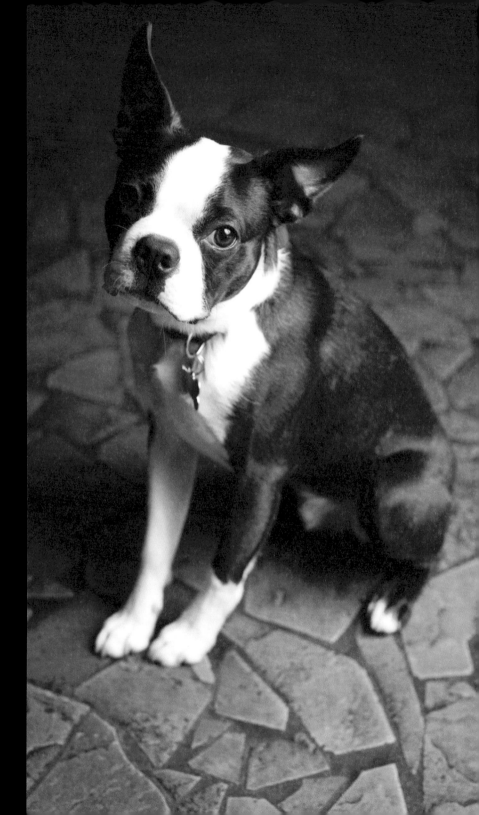

MURPHY

BAR GALLUS

Boston Terrier

Where do they sleep?
in his bed until I leave, then the sofa

Favourite things
anything he can chew, including
SD cards, passport & bank cards

Most dislikes
small children

Favourite place
under the bed, where I can't
get him

Favourite drink
puddles

When not in pub likes to
hassle me to go out. Whenever he
passes the pub, he will wait at the
door to get in, even if it's closed

Cats?
not really met one yet

Best trick
not fetch, not roll over. He can give
me a paw!

Favourite toy
he stole a glow in the dark dog ball
the other day, he loves it!

Favourite treat
crisps

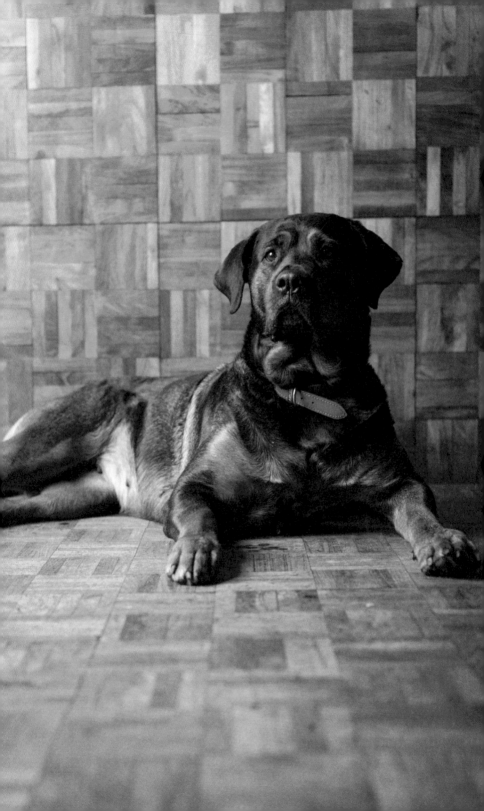

EMMYLOU BIG SLOPE

Rottweiler & Mastiff Cross

Where do they sleep?
my bed (now hers)

Favourite things
squirrels, laser pen

Most dislikes
foxes

Favourite place
anywhere there are squirrels,
especially the duck pond at
Kelvingrove Park

Favourite drink
water from the river Kelvin, but has
been known to quaff a soupçon
of Lager

When not in pub likes to
chase squirrels, play with Bouncy
Kong & laser pen

Cats?
intrigued

Best trick
she doesn't do tricks, she's a dog

Favourite toy
bouncy Kong

Favourite treat
roast beef

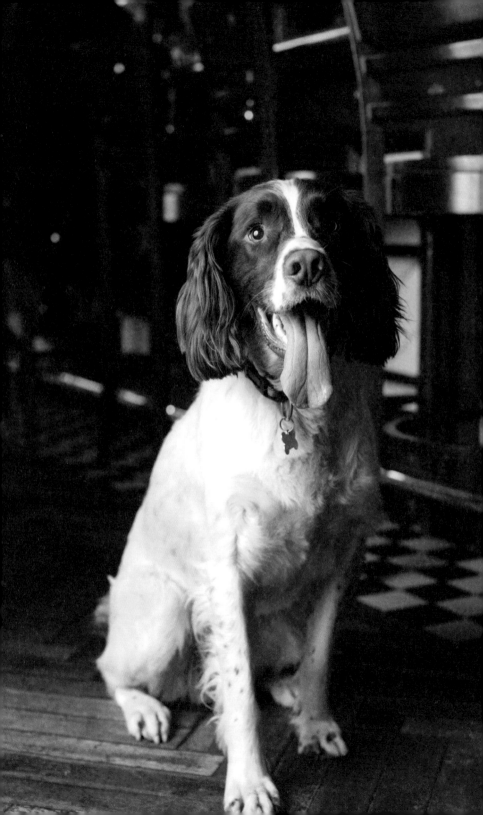

MURPHY

Springer Spaniel

KELVINGROVE CAFE

Where do they sleep?
downstairs

When not in pub likes to
run

Favourite things
ball

Cats?
not the best

Most dislikes
loud noise

Best trick
identifying toys

Favourite place
park

Favourite toy
ball

Favourite drink
water

Favourite treat
Gravy Bone

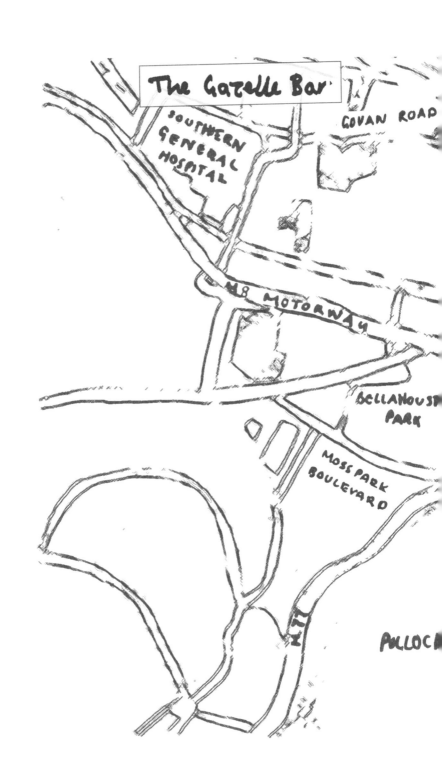

RIVER CLYDE

PACIFIC DRIVE

PAISLEY RD WEST

M77

The Allison Arms

NITHSDALE ROAD

The Bungo

POLLOKSHAWS ROAD

QUEEN'S PARK

The Quaich

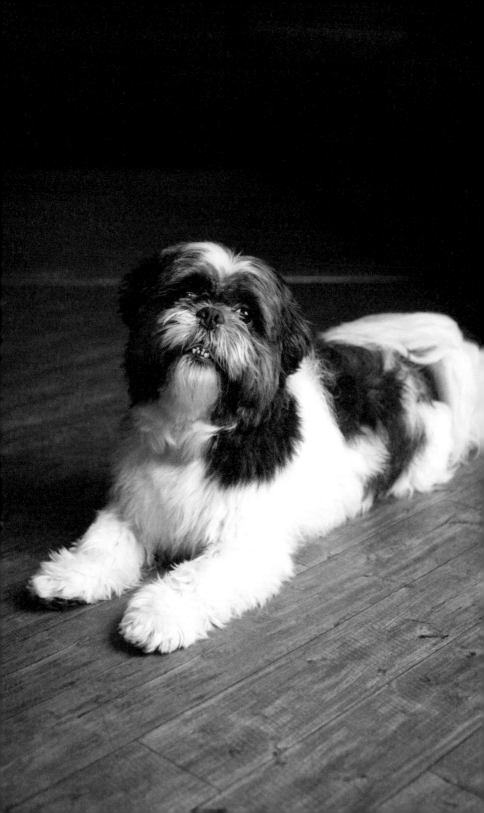

KAI

Shih Tzu

THE ALLISON ARMS

Where do they sleep?
I know he shouldn't, but in my bed!

Favourite things
to ride in the car with his head
hanging out the window

Most dislikes
men in yellow hi-vis
jackets-workmen

Favourite place
Pollok Park is his favourite place
in the world

Favourite drink
ice cold water & the occasional
slurp of cold tea!

When not in pub likes to
go walks in the park & meet up
with his other doggy pals & sniff,
sniff, sniff

Cats?
don't think he's every come across
a cat. Would probably be scared!

Best trick
definitely break dancing when it's
icy in the winter. Lies on his back
& wriggles around & rubs his face
in it.

Favourite toy
Panda – a soft toy he slobbers
all over

Favourite treat
a nice bit of chicken or a sausage!

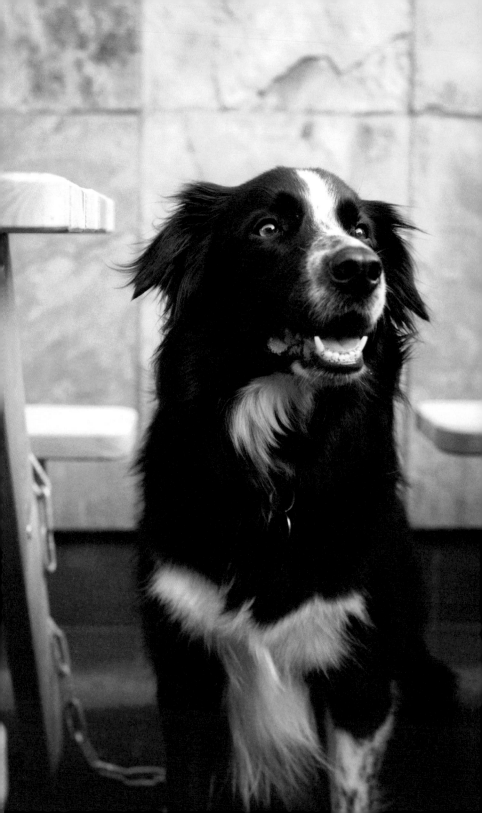

XANDER

THE QUAICH

Border Collie

Where do they sleep?
in bed with her head on her pillow

Favourite things
frisbee, toast with butter &
marmite, macaroni cheese

Most dislikes
cats

Favourite place
front passenger seat of car

Favourite drink
puppy milk

When not in pub likes to
go to Pollok Park to play in the river

Cats?
loathes

Best trick
catching his frisbee really high up

Favourite toy
frisbee

Favourite treat
black pudding & haggis chews

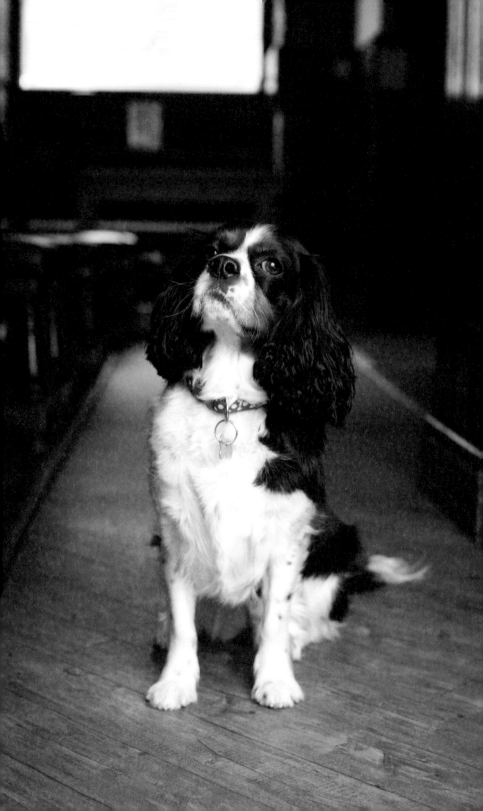

DARCY

*Cavalier King
Charles Spaniel*

THE ALLISON ARMS

Where do they sleep?
on couch

When not in pub likes to
go to park

Favourite things
exercise

Cats?
likes

Most dislikes
no treats

Best trick
giving kiss for treat

Favourite place
park

Favourite toy
ball

Favourite drink
milk

Favourite treat
chicken

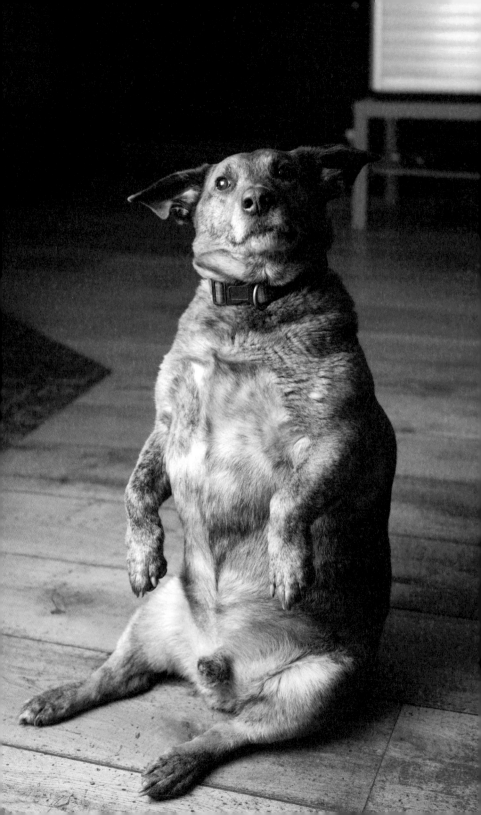

COISTY

THE GAZELLE BAR

Mixed

Coisty's Willy

Right ladies

Feast yir eyes on THIS

Huv yi evir seen anythin
like it in yir life?

Well huv yi?

Am rarin ti go!
Am a real dug
an am gonni prove it

right aiftir am taken
ti bi Seen To ramorra

Ah heard thum say this wurd
(or is it three wurds?)
Kass
 Tray
 Shun
as they lookt in ma direckshun

Yeah whitevir
Bring it on

Move over Casanova!
Coisty's back in town

COISTY

Where do they sleep?
own bed

Favourite things
pub

Most dislikes
leaving the pub

Favourite place
park

Favourite drink
water

When not in pub likes to
park

Cats?
don't like cats

Best trick
the Meerkat

Favourite toy
none

Favourite treat
biscuits

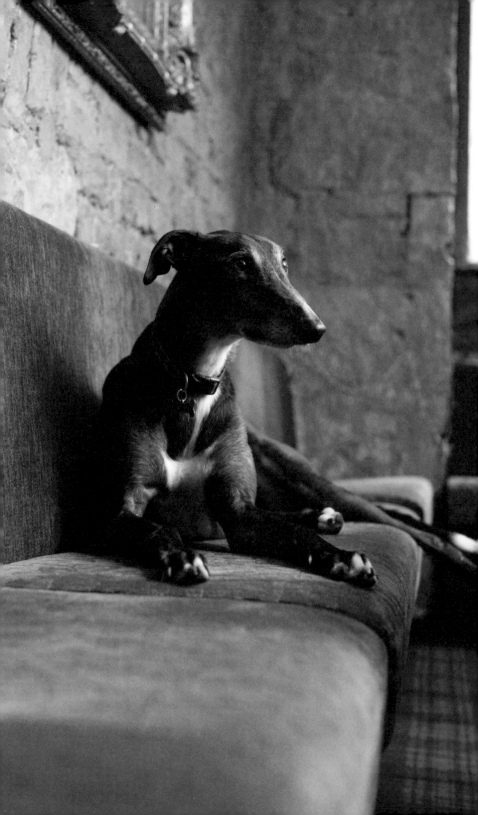

ARROW

Greyhound

THE ALLISON ARMS

Where do they sleep?
has a bed in every room, vehicles,
the pub, & steals other dogs' beds

Favourite things
food & a lot more food. Sausage
& Haggis. Scraping kebab & pizza
from the ground.

Most dislikes
nervous people & drugs

Favourite place
the Allison Arms

Favourite drink
puddle water

When not in pub likes to
sleep. Also sleeps in pub.

Cats?
likes Scunner & Menace. Will
tolerate Yoda (but not after 9pm...).
Other cats? it depends...

Best trick
best dog (is running with front
paws up) & Dance dog (is chasing
tail, reversing direction, chasing
tail...)

Favourite toy
toys are for losers

Favourite treat
something that another dog might
have been given...

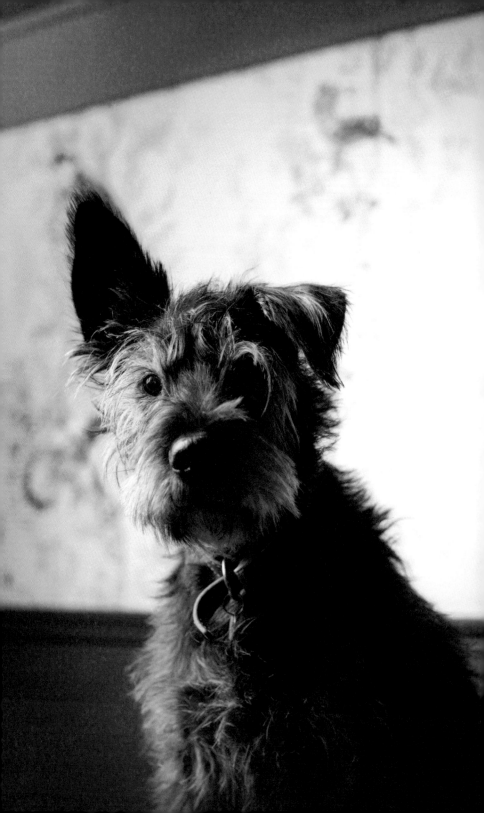

EDDIE

THE BUNGO

Schnauzer Cross

Where do they sleep?
at night – at the end of my bed.
During the day – wherever he can
find a sunny spot around the flat.

When not in pub likes to
demand cuddles & head pats
from strangers, chase squirrels
& pigeons in Queens Park

Favourite things
adventures, cuddles, belly rubs,
naps, chasing squirrels, hoarding
toys, his best friend Wooster the
Whippet

Cats?
if they run, he will chase them.
If they are bold, he will sniff them
& then cuddle up.

Most dislikes
baths & being ignored

Best trick
sits up tall & begs with both paws

Favourite place
Troon Beach

Favourite toy
Mr. Duck

Favourite drink
water (especially muddy puddles)

Favourite treat
lettuce. Or chicken.

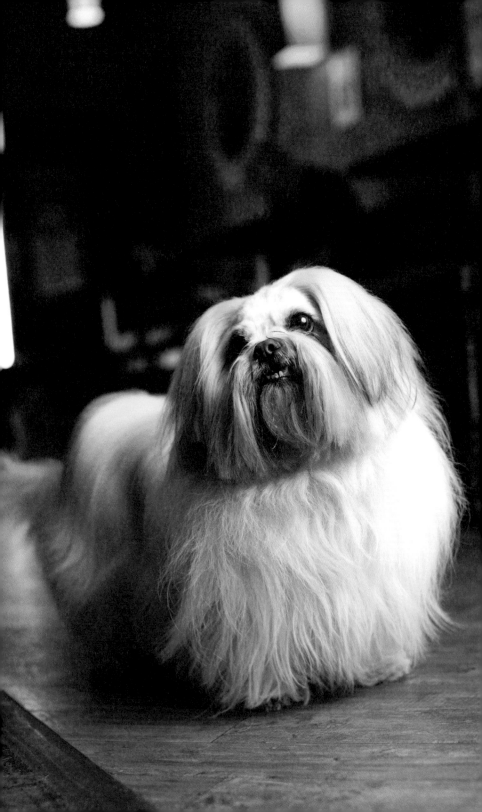

CHARLIE

THE ALLISON ARMS

Shih Tzu

Where do they sleep?
with Tippy or me

Favourite things
playing chases, climbing

Most dislikes
nothing, behaving

Favourite place
Pollok Estate, Carbeth, Beach,
Home

Favourite drink
weak Horlicks

When not in pub likes to
run & play cuddle together

Cats?
never really met one

Best trick
too laid back

Favourite toy
not much of a player

Favourite treat
Schmackos, Gravy Bones

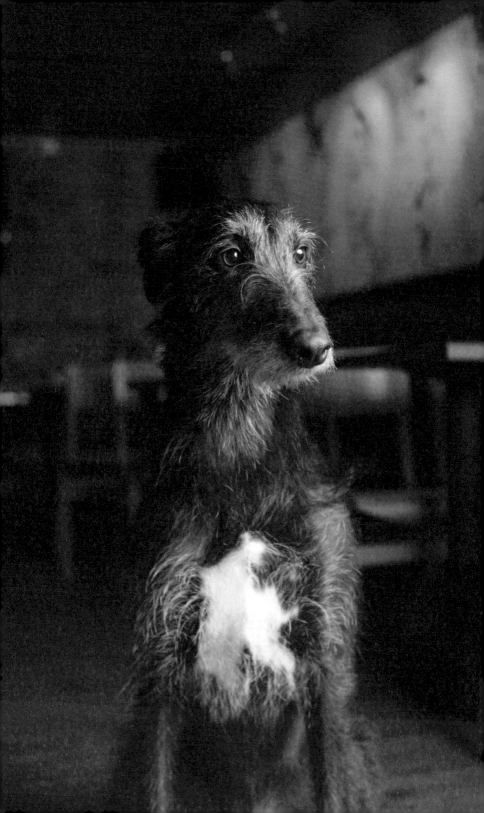

AVA

Lurcher

THE BUNGO

Where do they sleep?
in the beds, on the couches.
Basically wherever she likes.

Most dislikes
probably having her photograph
taken

Favourite place
Queen's Park

Favourite drink
oh, can't divulge that

When not in pub likes to
go walks

Cats?
not fussed either way

Best trick
doesn't do tricks

Favourite toy
she's not into toys. Too intelligent.

Favourite treat
coming to the pub

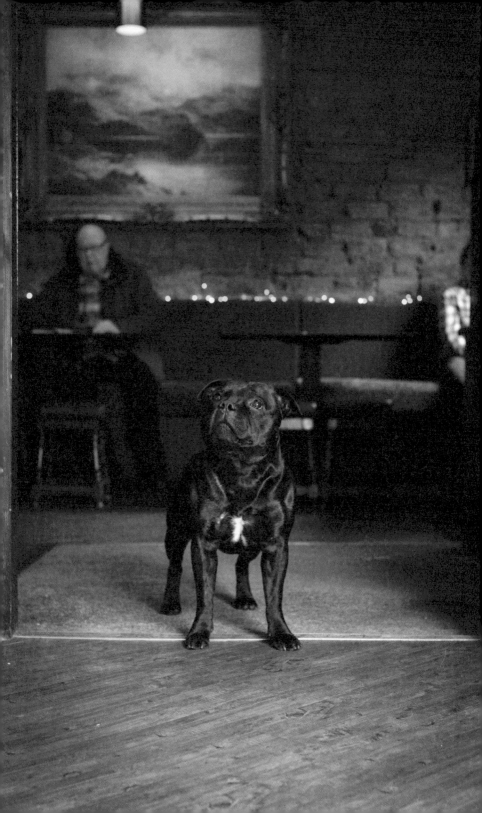

DIESEL

THE ALLISON ARMS

Staffordshire Bull Terrier

Diesel's Dogma

I say who gets in,
and who gets out.
Who can play dominoes,
and who can't.

I'm a capo, a guardian.
Sleek and shiny
and blacker than Guinness.

I can smell
who supports Rangers
and who supports Celtic.

I can smell
who hasn't washed their hands.
I can smell
your blood sugar.
I can smell
dividing cells.

I can smell your fear.
I can smell
who supports Partick Thistle.

Look me in the eye
if you want to die.

I'm in control

until my master says
it's time to go home.

I'm the Cerberus of the Clyde.
A myth in Staffie's clothing.

DIESEL

Where do they sleep?
cage in gym

Favourite things
sardines + tug-of-war

Most dislikes
being left alone

Favourite place
pub!

Favourite drink
Guinness – when allowed

When not in pub likes to
run

Cats?
likes

Best trick
scrounging for food

Favourite toy
rope!

Favourite treat
salmon

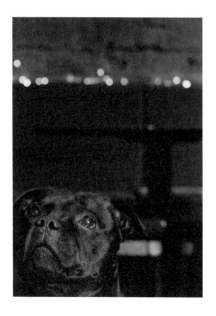

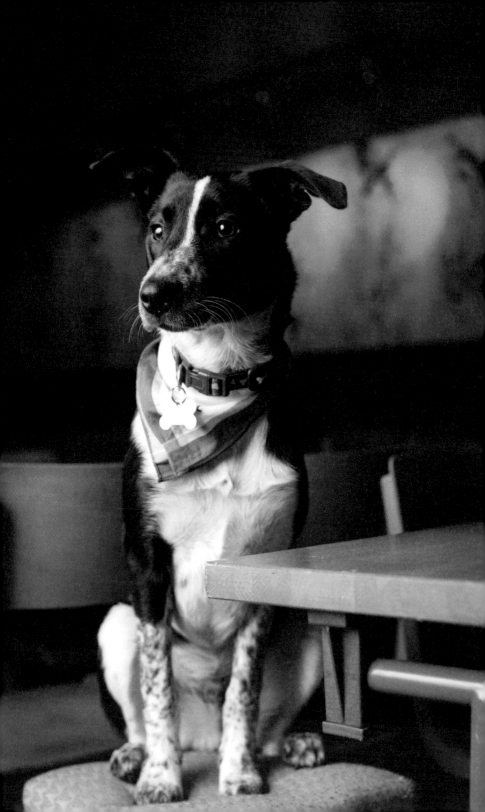

BOSTON

THE BUNGO

Smooth Collie

Where do they sleep?
bedroom

Favourite things
escaping from the garden.
He is a master of escape.

Most dislikes
guys in baggy trousers

Favourite place
garden – whenever he can dig
& destroy our plants

Favourite drink
milk – which he steals from the
cats' bowl

When not in pub likes to
going to Maxwell Park

Cats?
likes cats – he lives with three

Best trick
high five

Favourite toy
socks

Favourite treat
cat poo – especially when it's
a fresh one!

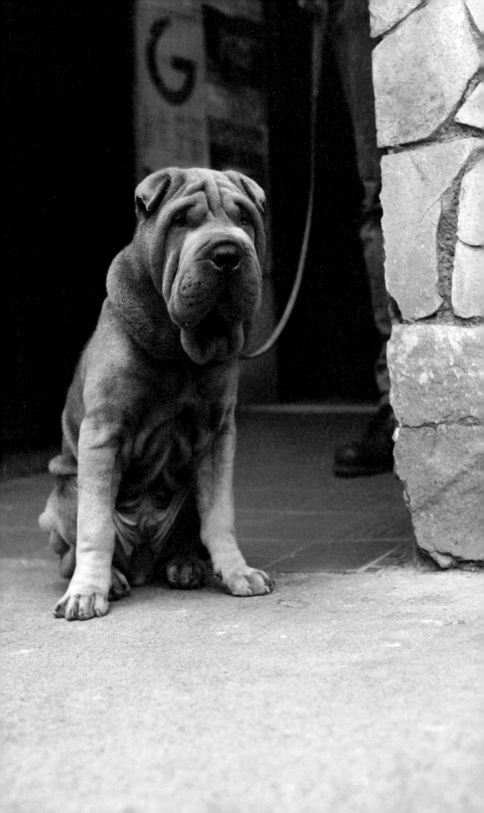

HANK

THE ALLISON ARMS

Shar Pei

Where do they sleep?
anywhere he chooses

Favourite things
pants (frilly ones)

Most dislikes
pigeons

Favourite place
home

Favourite drink
water

When not in pub likes to
run & hump

Cats?
loathes

Best trick
high five

Favourite toy
stuffed Rhino

Favourite treat
dental sticks (baw rub)

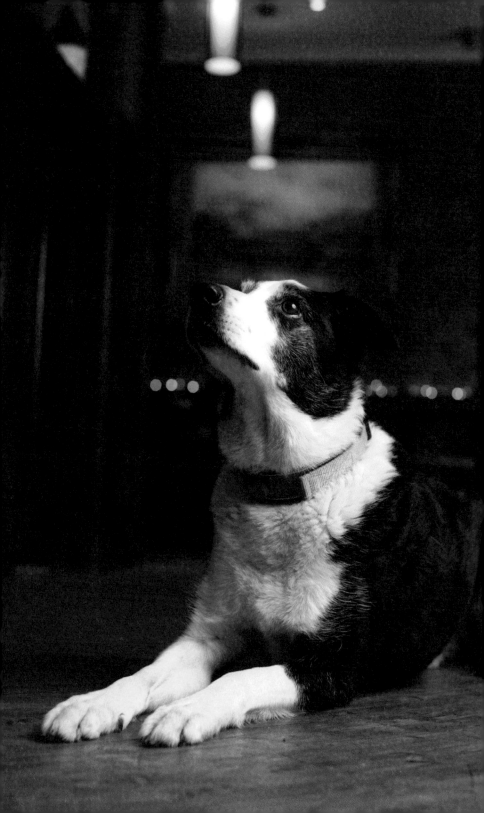

FIONN

THE ALLISON ARMS

Border Collie

Where do they sleep?
bottom of my daughter's bed

Favourite things
swimming, chasing balls,
big long walks

Most dislikes
crows & policemen

Favourite place
the Highlands

Favourite drink
milk

When not in pub likes to
go for big walks or swimming
in seas, lochs & rivers

Cats?
loathes but enjoys giving them
a good chase

Best trick
climbing ladders

Favourite toy
ball

Favourite treat
cheese

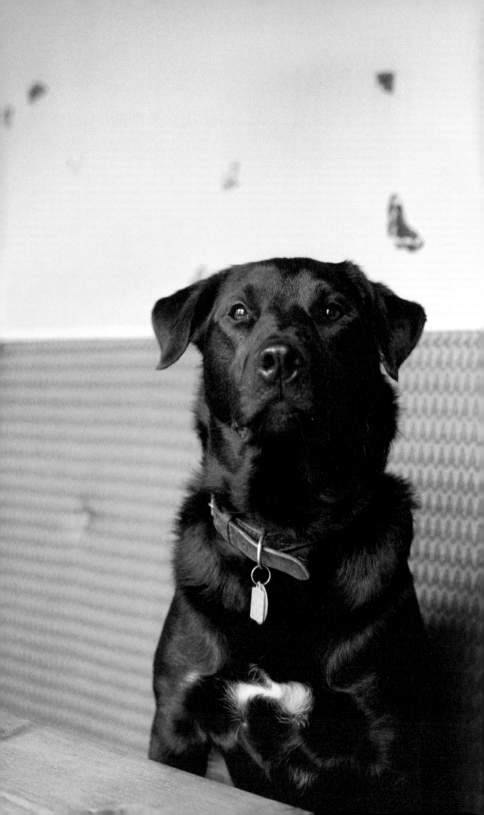

BUSTER THE BUNGO

Patterdale Cross

Where do they sleep?
on the chaise longue in
Catherine's room

Favourite things
squeaky toys, footballs, rolling in
icy grass, playing dunk 'the ball in
the river', agility classes, tug

Most dislikes
people on crutches, women in
burkhas, Cranes & Tesco

Favourite place
on Catherine's bed

Favourite drink
puddle water

When not in pub likes to
be in the park

Cats?
loves cats

Best trick
ready, steady, go

Favourite toy
floating Kong

Favourite treat
sausages & cheese

PUBS

Bar 91
Candleriggs,
Glasgow. G1 1NP

Bar Gallus
80 Dumbarton Rd,
Glasgow. G11 6NX

Big Slope
36A Kelvingrove St,
Glasgow. G3 7SA

Brewdog
1397-1403 Argyle St,
Glasgow. G3 8AN

Brunswick Hotel
106/108 Brunswick St,
Glasgow. G1 1TF

Brutti Compadres
43 Virginia St,
Glasgow. G1 1TS

Chinaski's
239 North St,
Glasgow. G3 7DL

Distill
1102-1106 Argyle St,
Glasgow. G3 7RX

Dukes Bar
41 Old Dumbarton Rd,
Glasgow. G3 8RD

Firebird
1321 Argyle St,
Glasgow. G3 8AB

Inn Deep
445 Great Western Rd,
Glasgow. G12 8HH

Kelvingrove Café
1163 Argyle St,
Glasgow. G3 8TB

Stravagin
28 Gibson St,
Glasgow. G12 8NX

The 78
10-14 Kelvinhaugh St,
Glasgow. G3 8NU

The Allison Arms
720 Pollokshaws Rd,
Glasgow. G41 2AD

The Ben Nevis
1147 Argyle St,
Glasgow G3 8TB

The Bungo
17-21 Nithsdale Rd,
Glasgow. G41 2AL

The Gazelle Bar
1213 Govan Road,
Glasgow. G51 4PW

The Grove
1092 Argyle St,
Glasgow. G3 8LY

The Lampost
37 Saltmarket,
Glasgow. G1 5NA

The Left Bank
33 Gibson St,
Glasgow. G12 8NU

The Quaich
52 Coustonholm Rd,
Glasgow. G43 1UF

The Sparkle Horse
Dowanhill St, Glasgow.
G11 5QR

The Three Judges
141 Dumbarton Road,
Glasgow. G11 6PR

The Ubiquitous Chip
12 Ashton Ln, Glasgow.
G12 8SJ

Thornwood Bar
724 Dumbarton Rd,
Glasgow. G11 6RB

WEST Brewery
15 Binnie Place,
Glasgow. G40 1AW